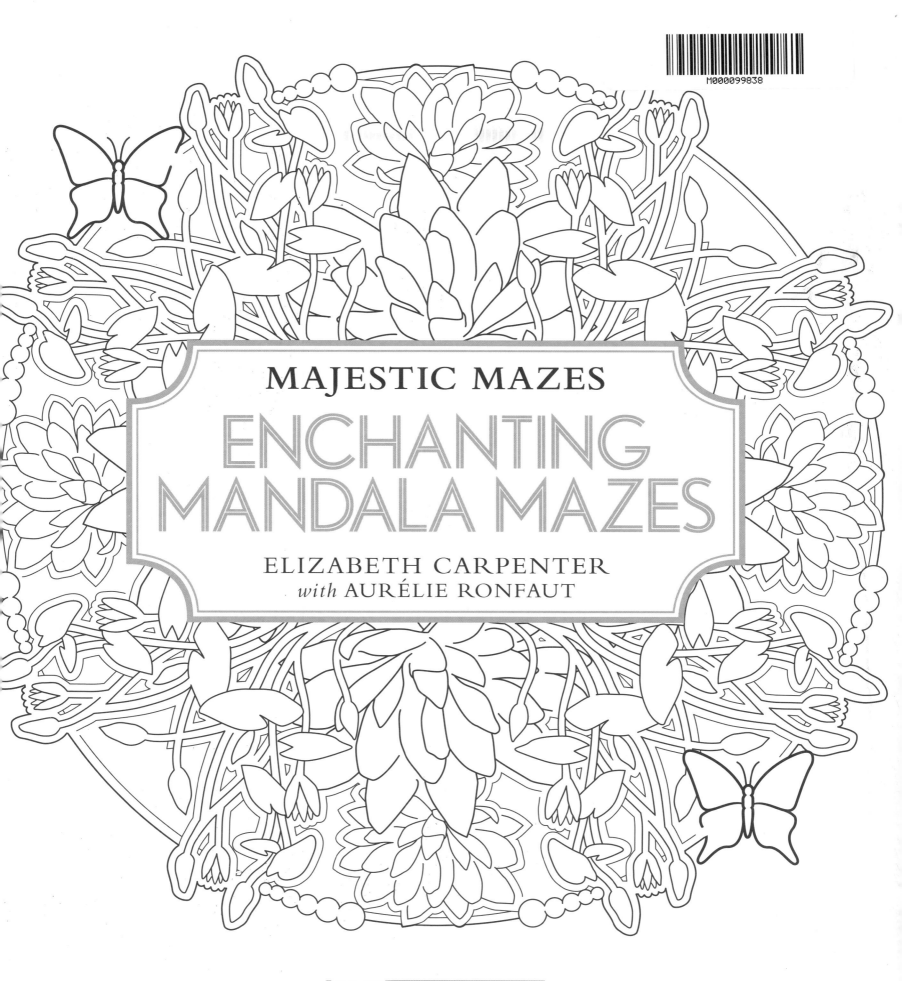

MAJESTIC MAZES

ENCHANTING MANDALA MAZES

ELIZABETH CARPENTER
with AURÉLIE RONFAUT

Get Creative 6

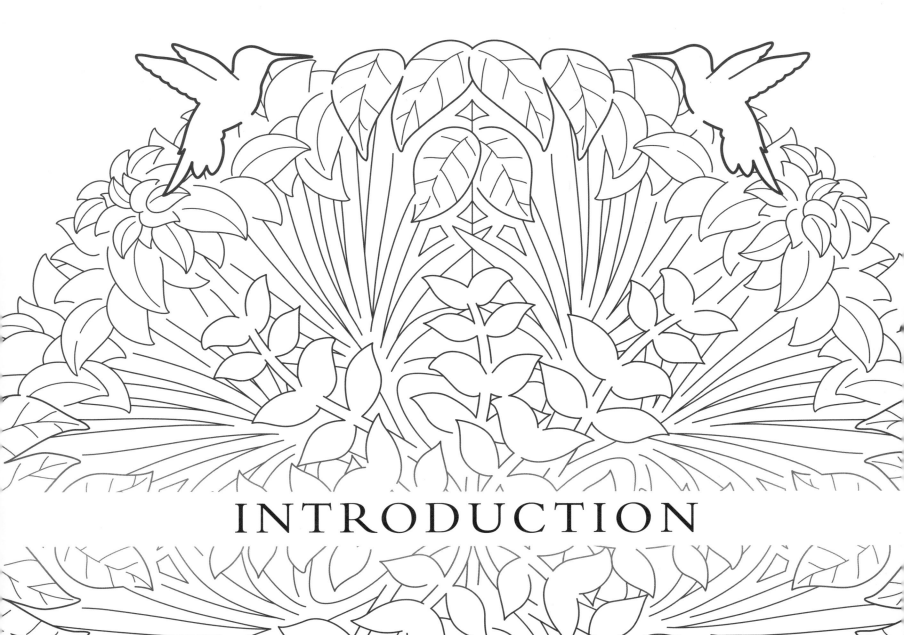

INTRODUCTION

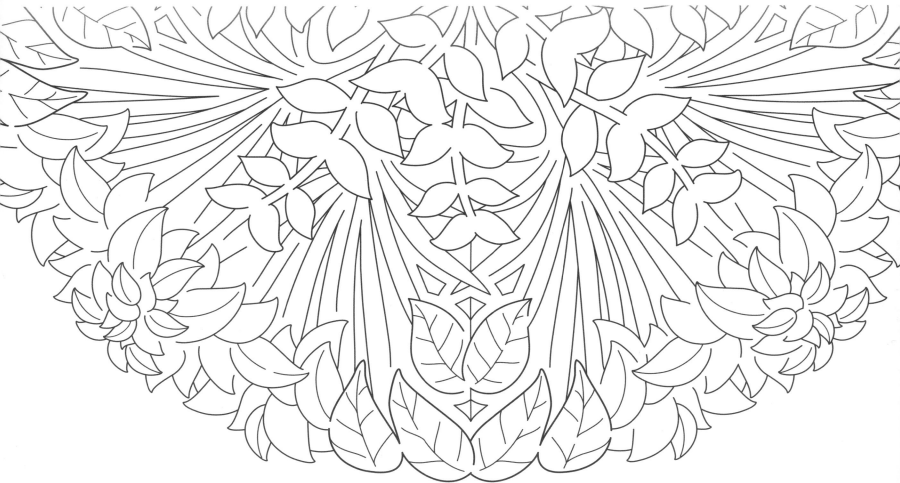

People all over the world have been making labyrinths and mazes for thousands of years. Labyrinths tend to be designed to be meditative and are often made with a single path.

Mazes, on the other hand, are puzzles. Most people think of mazes as a path within a geometric form, but for more than twenty-five years, I have been creating illustration-based mazes. These are different from geometric-based mazes, because I turn line-art illustrations into maze puzzles. And when I am the most successful, it is not immediately apparent that the illustration is a maze.

To create my mazes, I start with a line drawing. Then I adjust it to allow for room between the lines for the maze path and dead ends. (The degree of difficulty depends on the number of dead ends.)

Lastly, when plotting the maze path, I try to cut the lines at places where they may naturally break when drawing. This is one of the secrets to designing a successful illustration-based maze. As we acquire visual experience with age, our eyes naturally connect these breaks. However, children often find my mazes easier to solve than adults do because children tend to see things more literally—their brains don't fill in the gaps.

Usually, I create the illustrations for the mazes myself, but the mazes in this book are based on beautiful mandalas created by the French artist Aurélie Ronfaut, who created them by repeating imagery four to eight times within the structure of a circle. In order to keep the maze path from being obvious, I used a mirror technique for the maze path and dead ends within the illustration. Because some people choose to find the maze path from the end point, I make my mazes equally difficult from the finish as the start. **To solve the maze, start at one of the two symbols (hummingbird, star or butterfly) and find the path to the second symbol.** If you find yourself at a dead end, don't get discouraged—backtrack and go along a different route, and you will eventually discover the answer.

—Elizabeth Carpenter

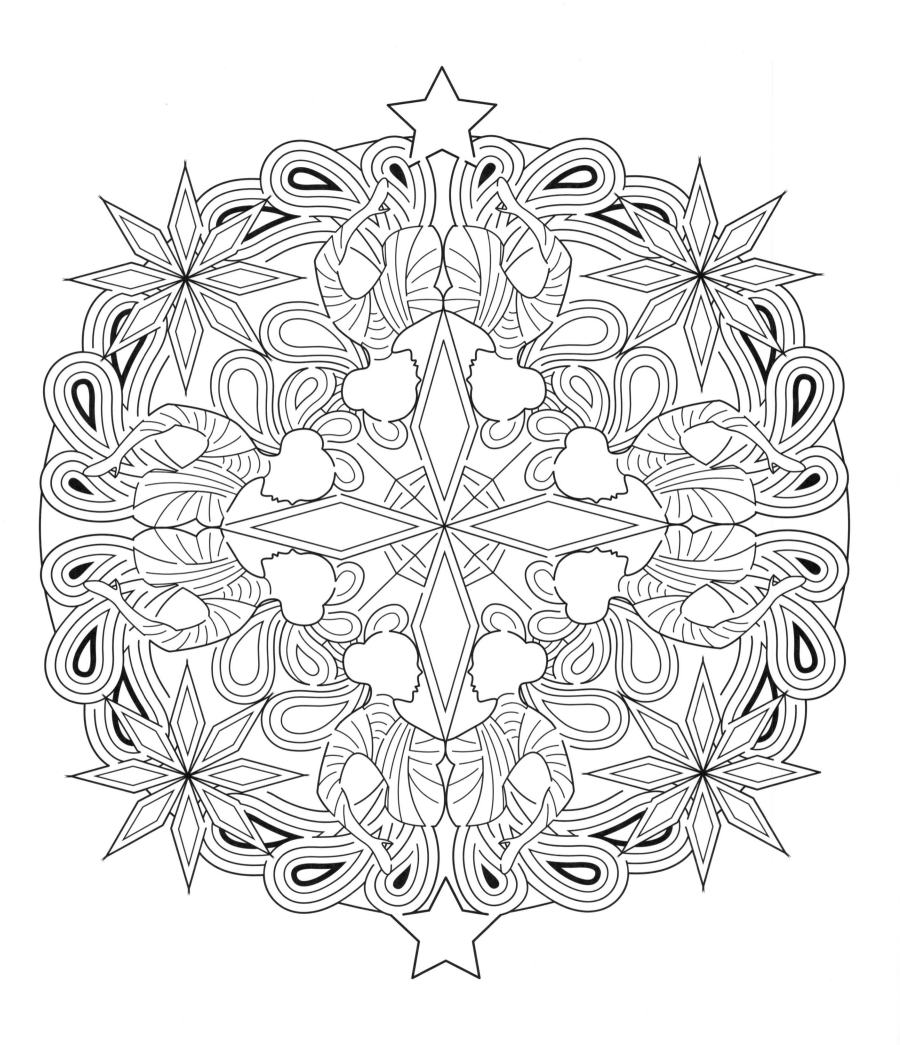

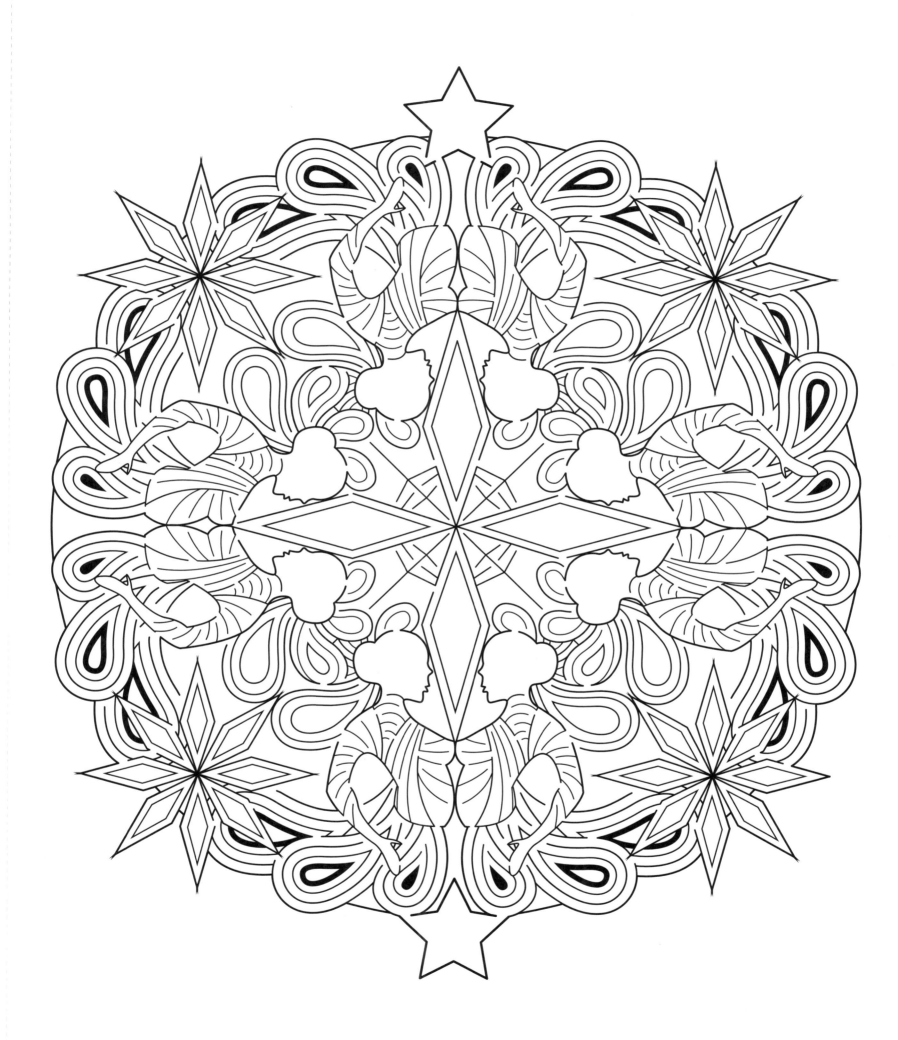

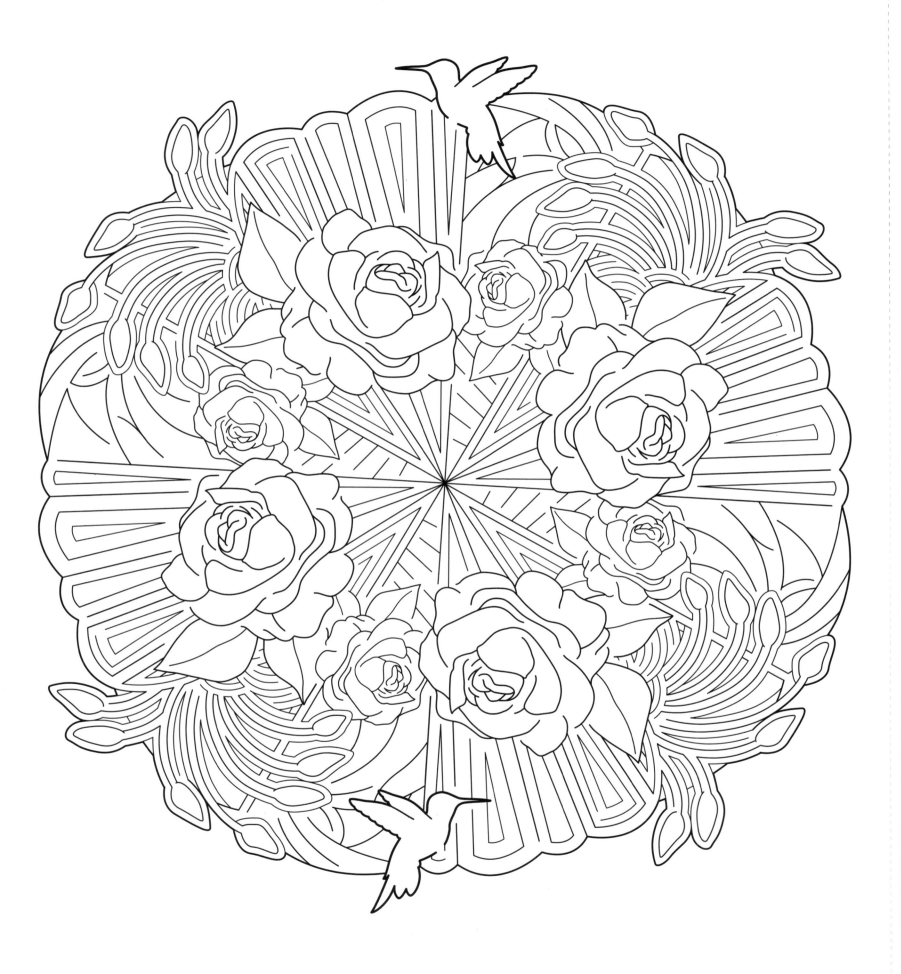

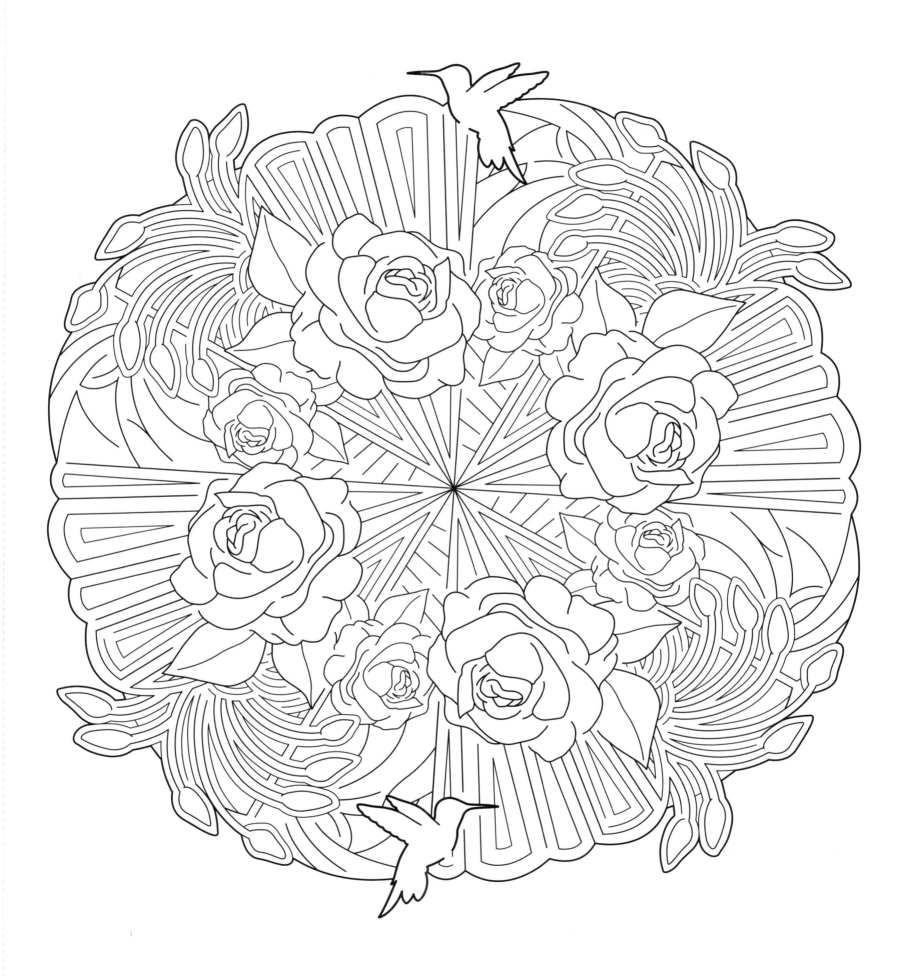

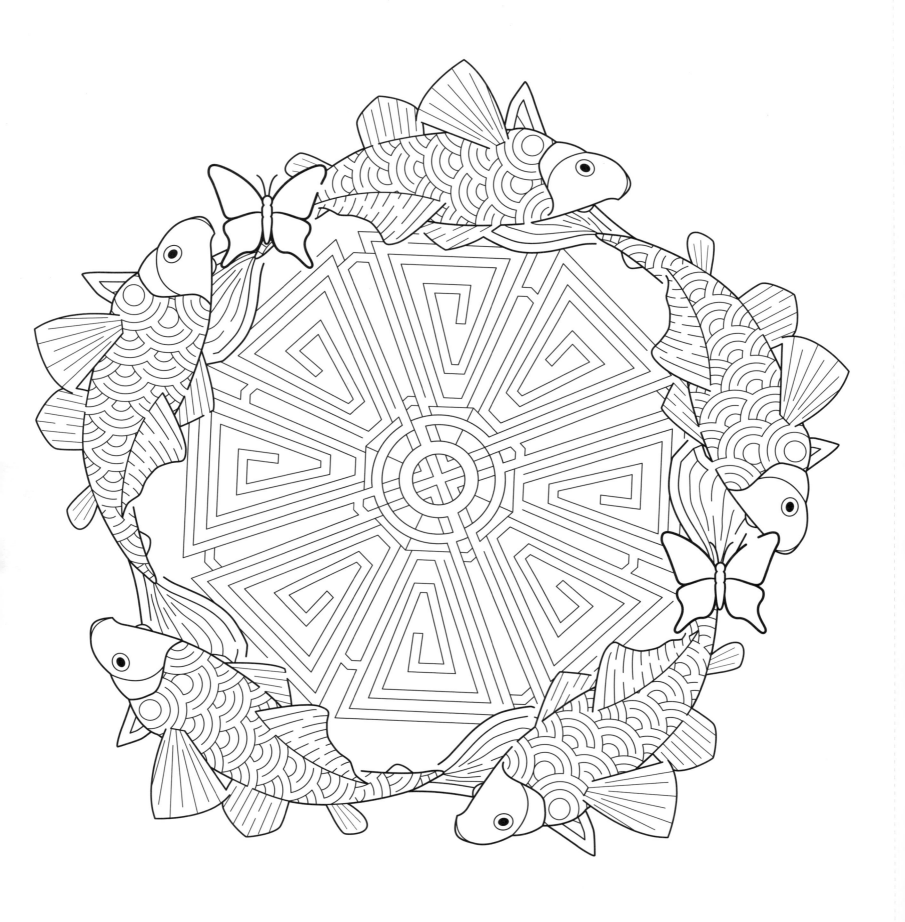

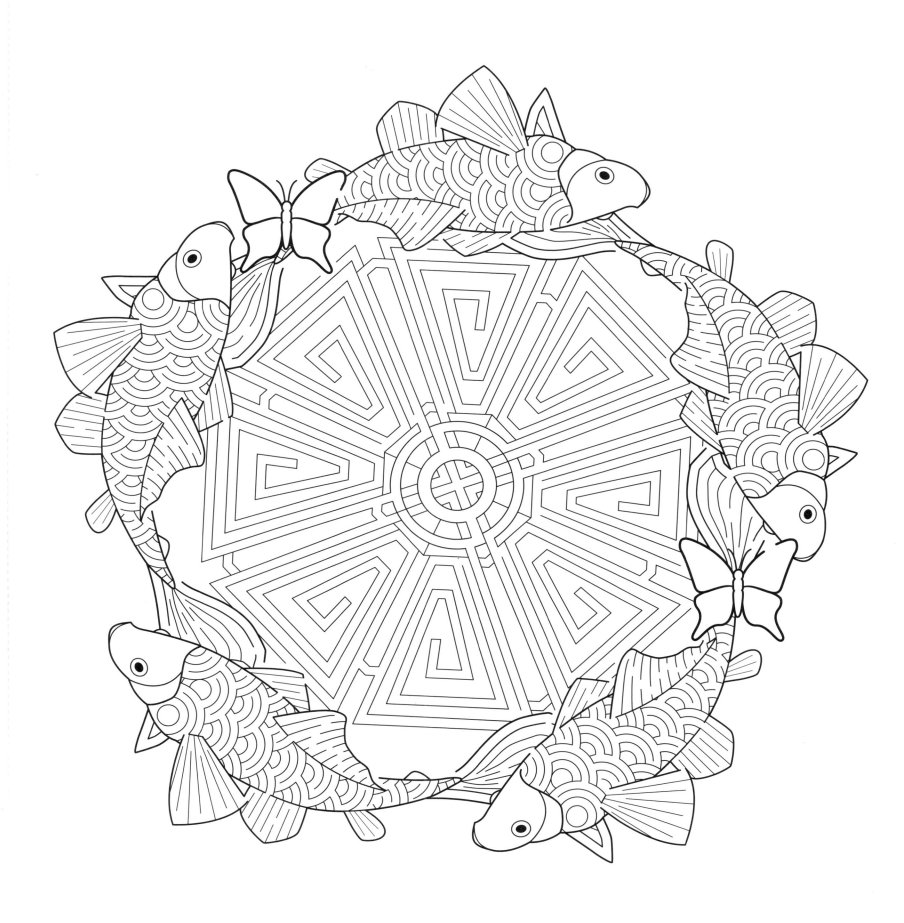

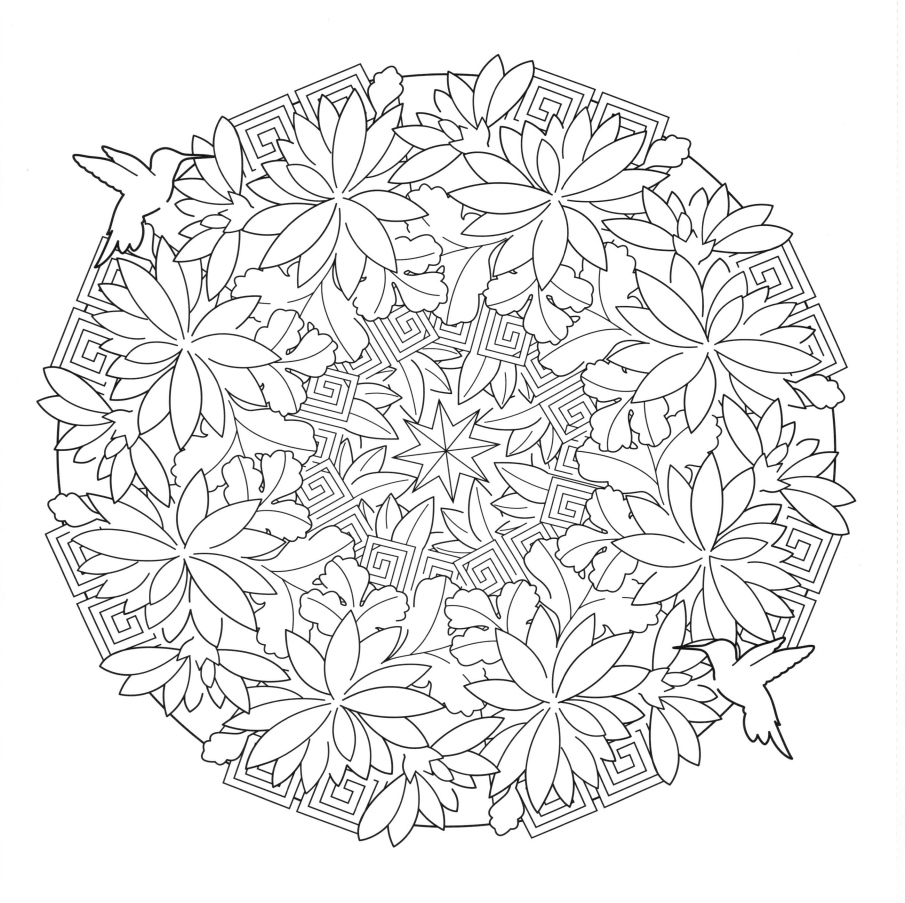

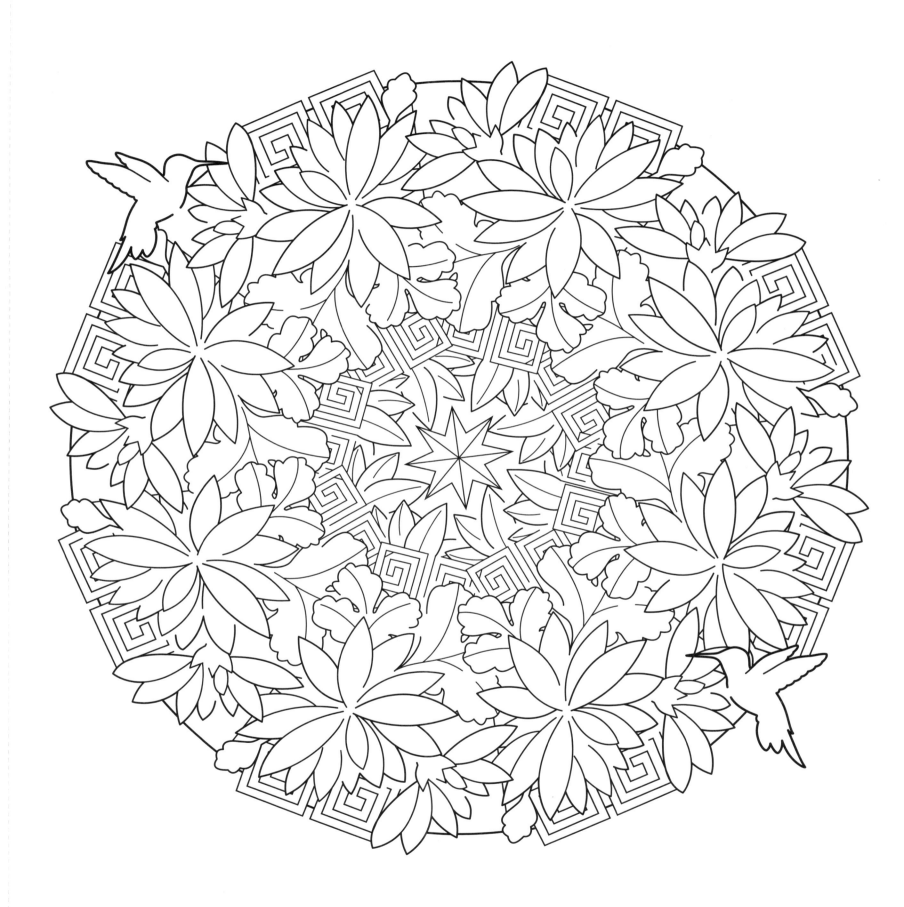

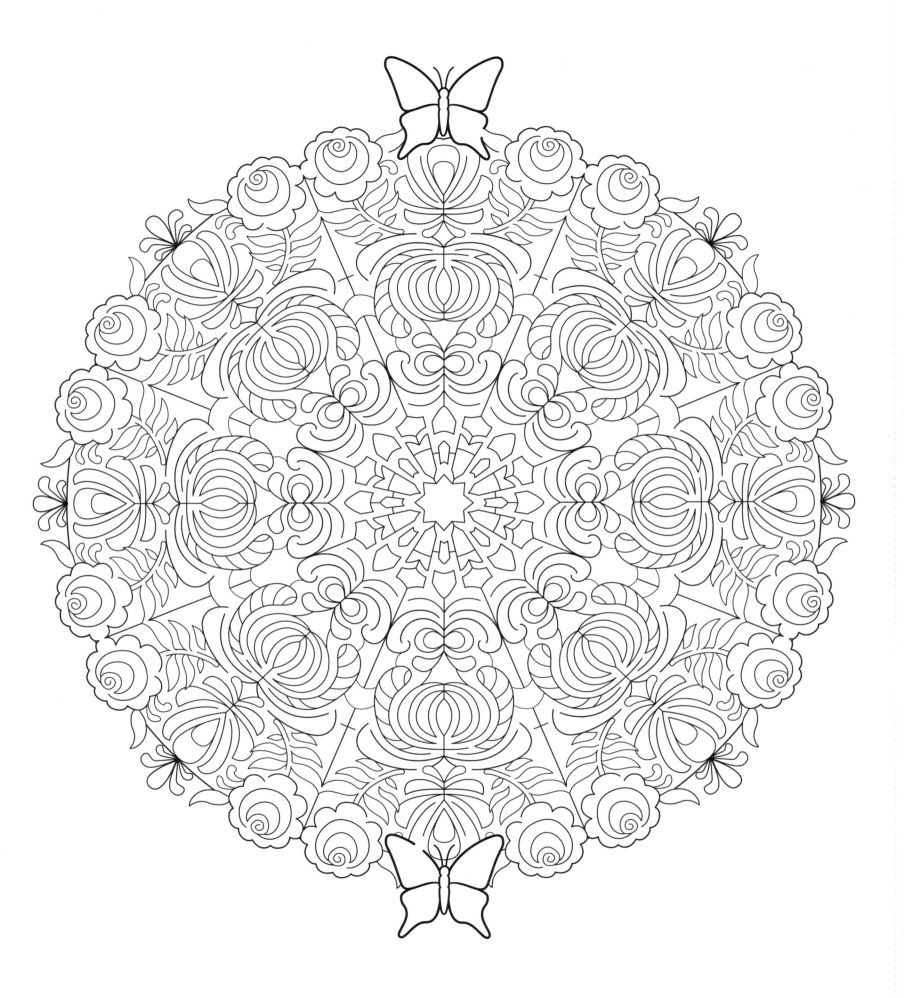

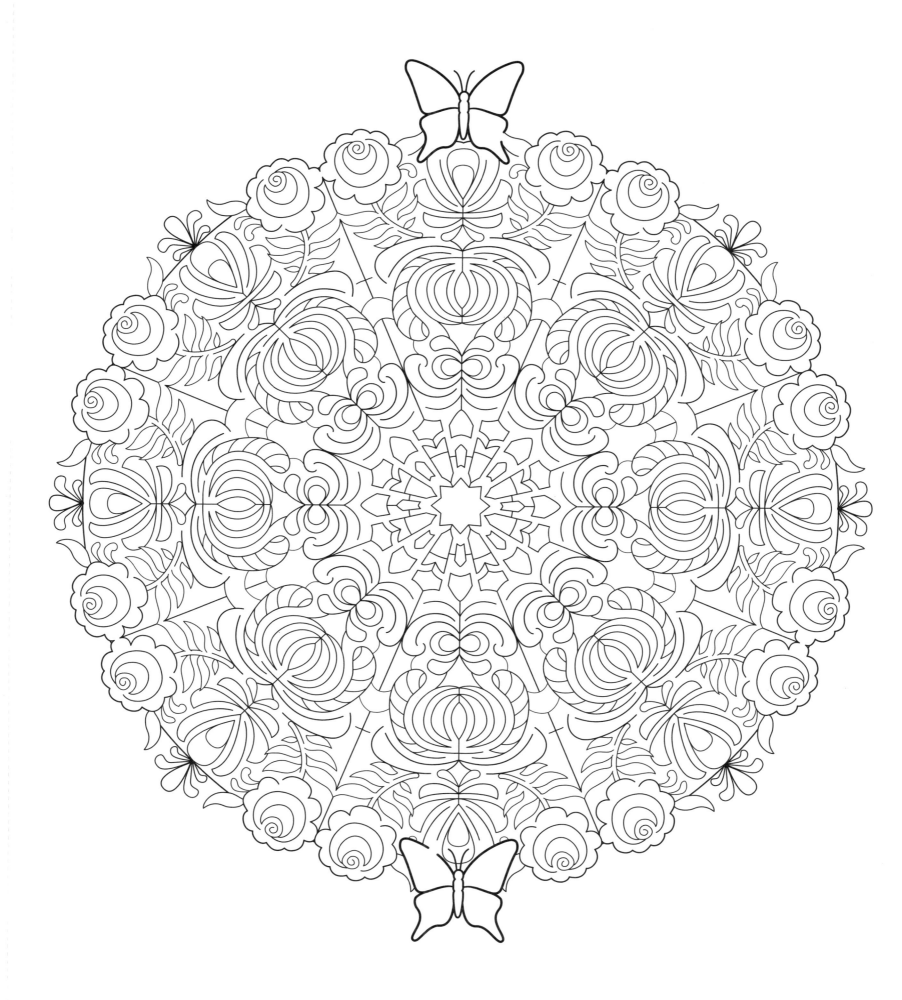

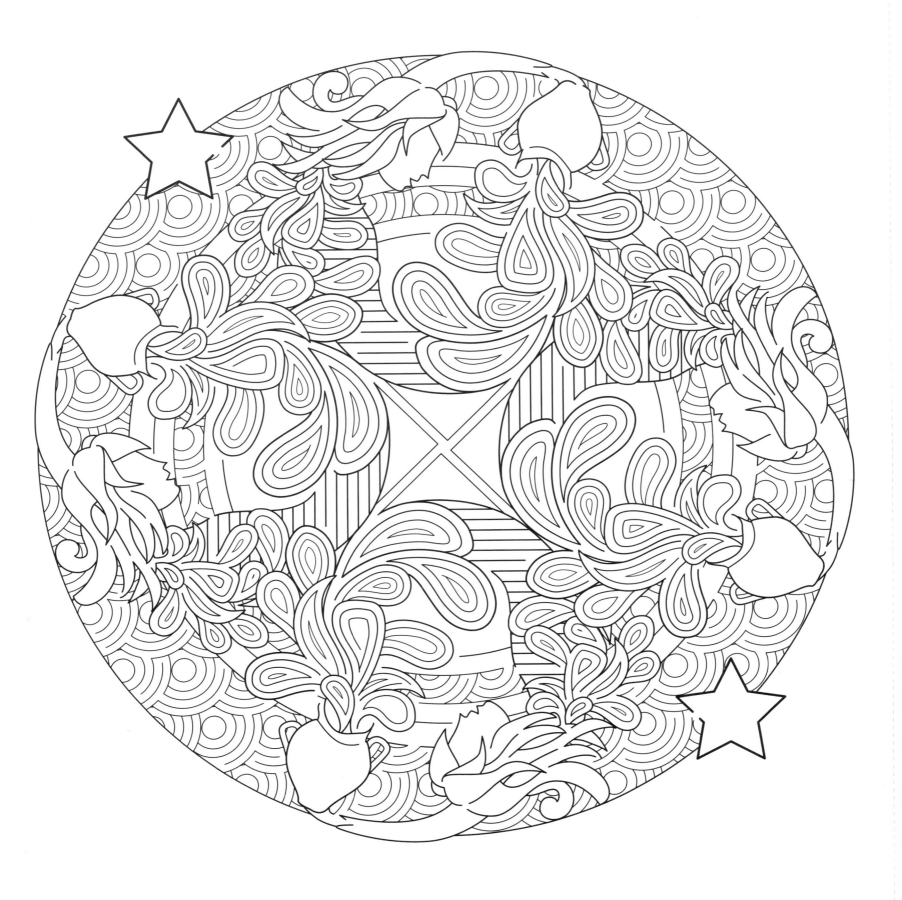

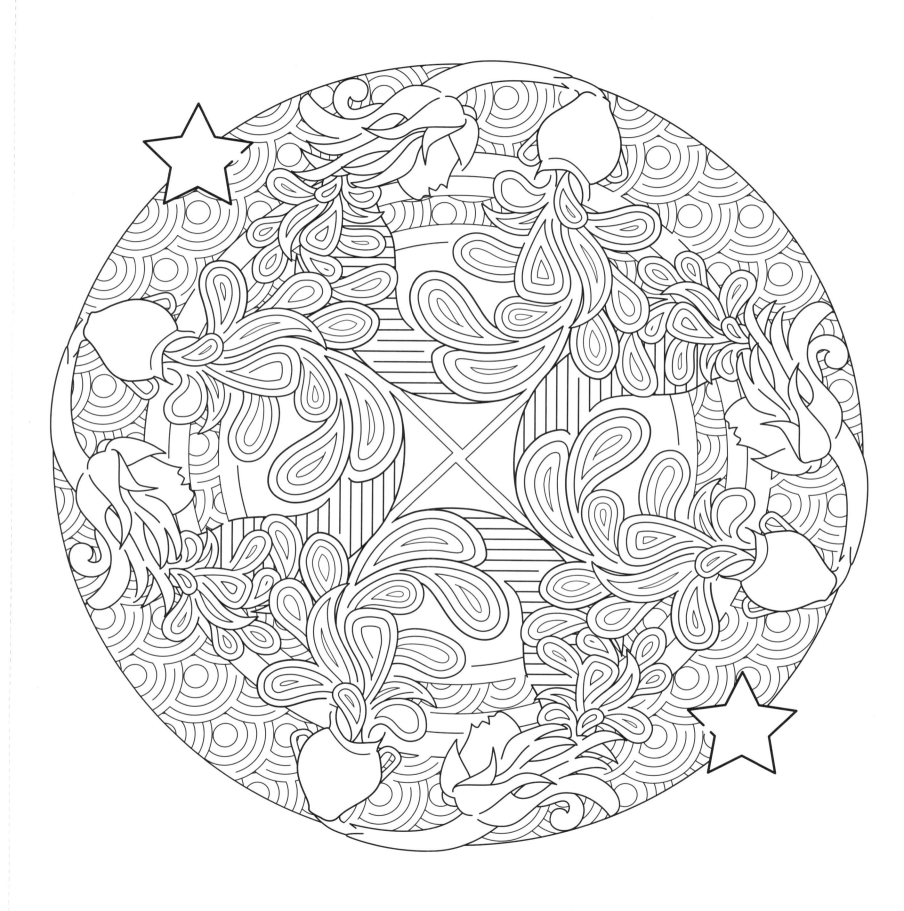

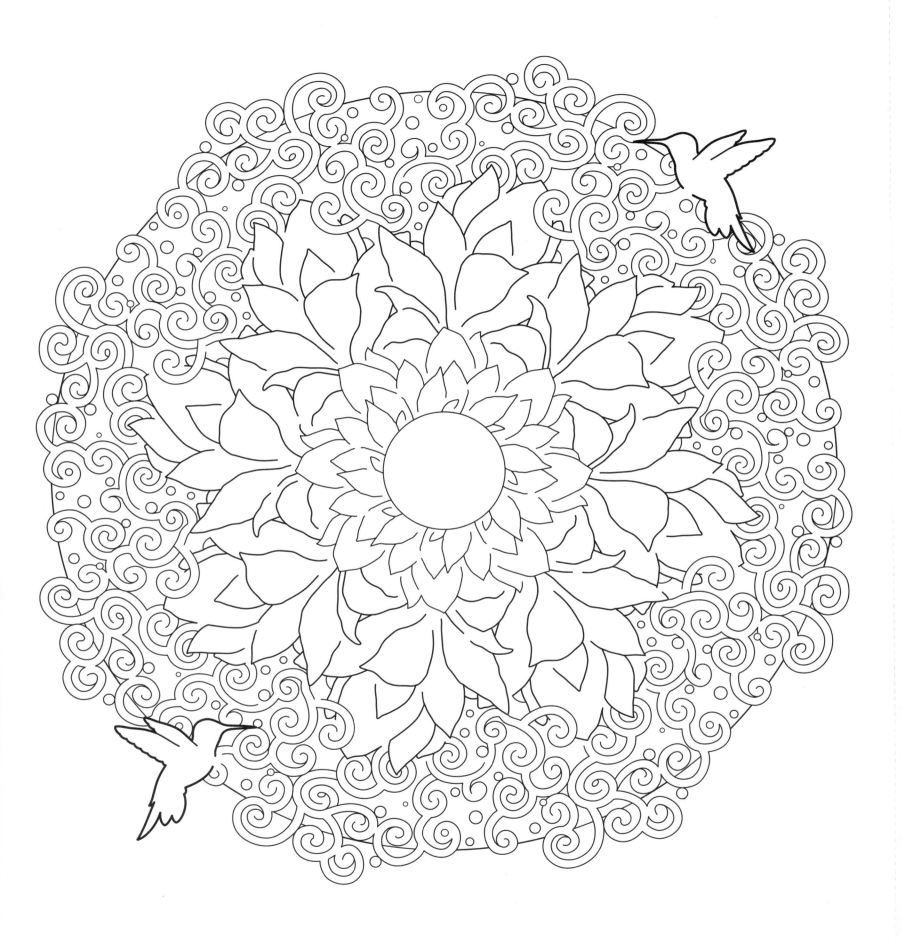

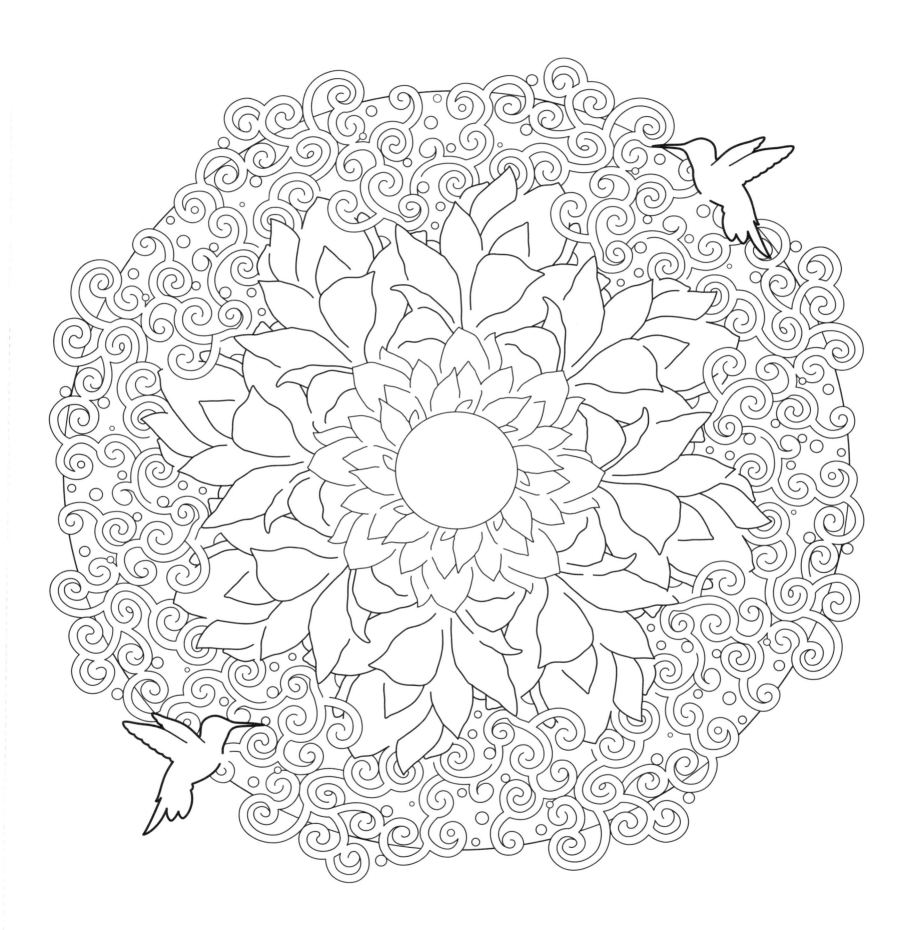

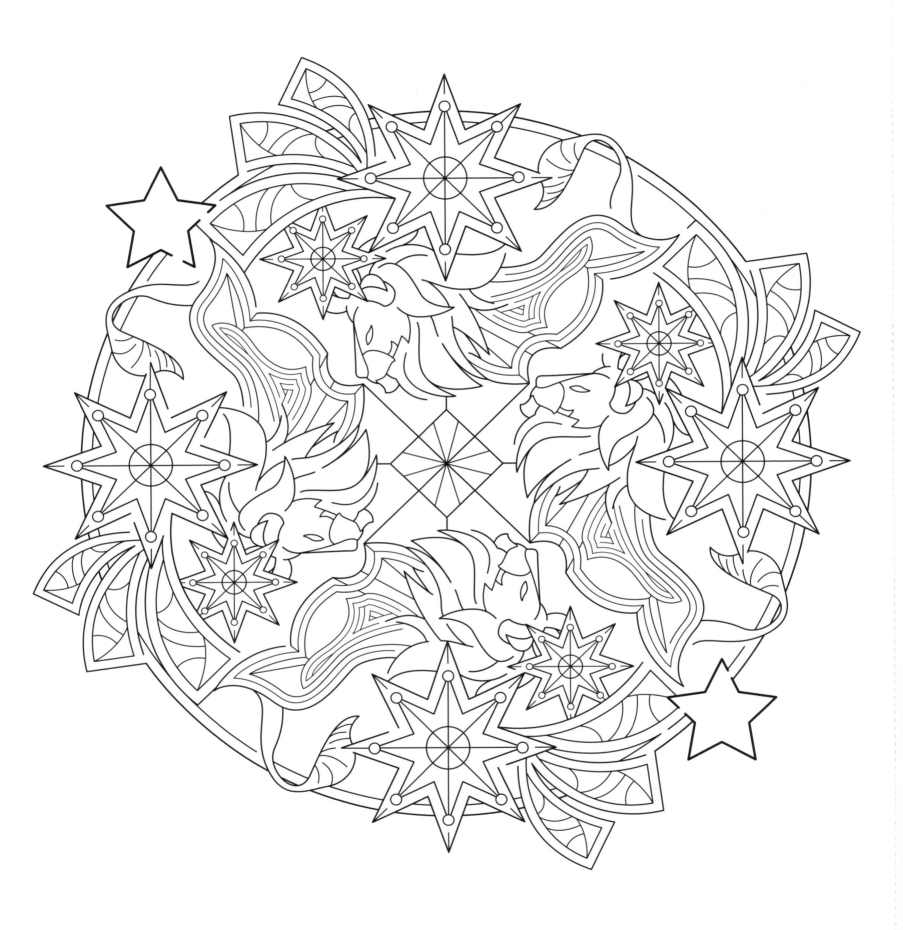

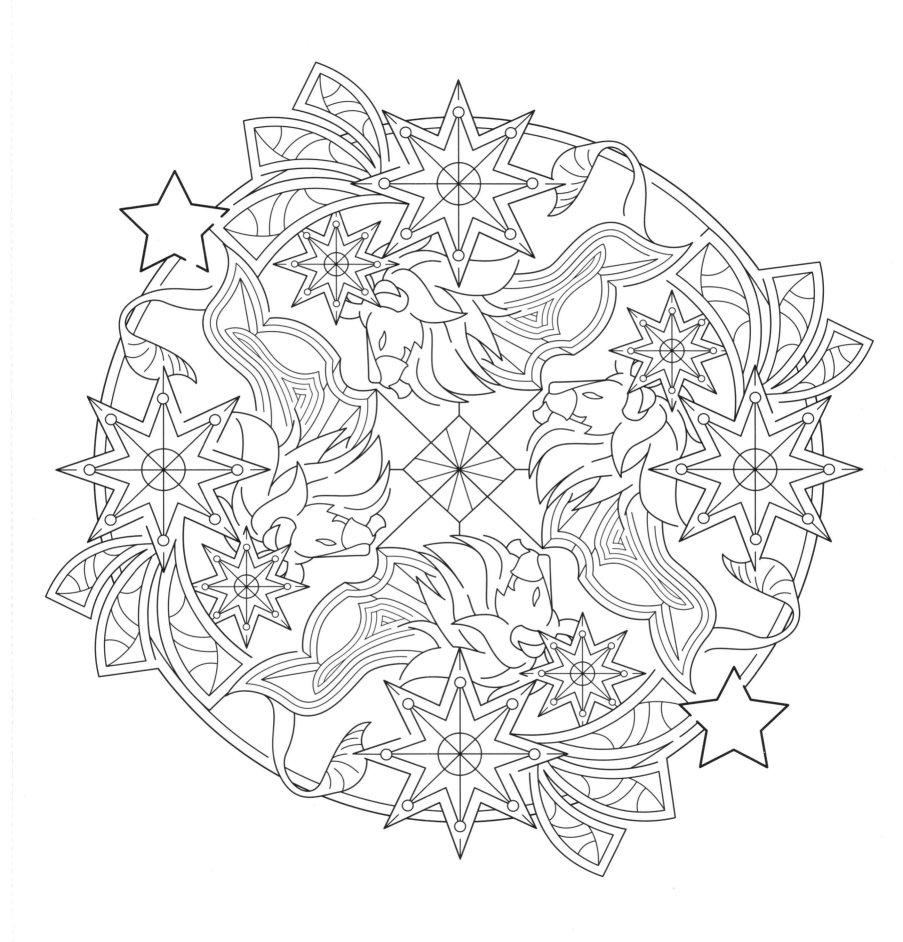

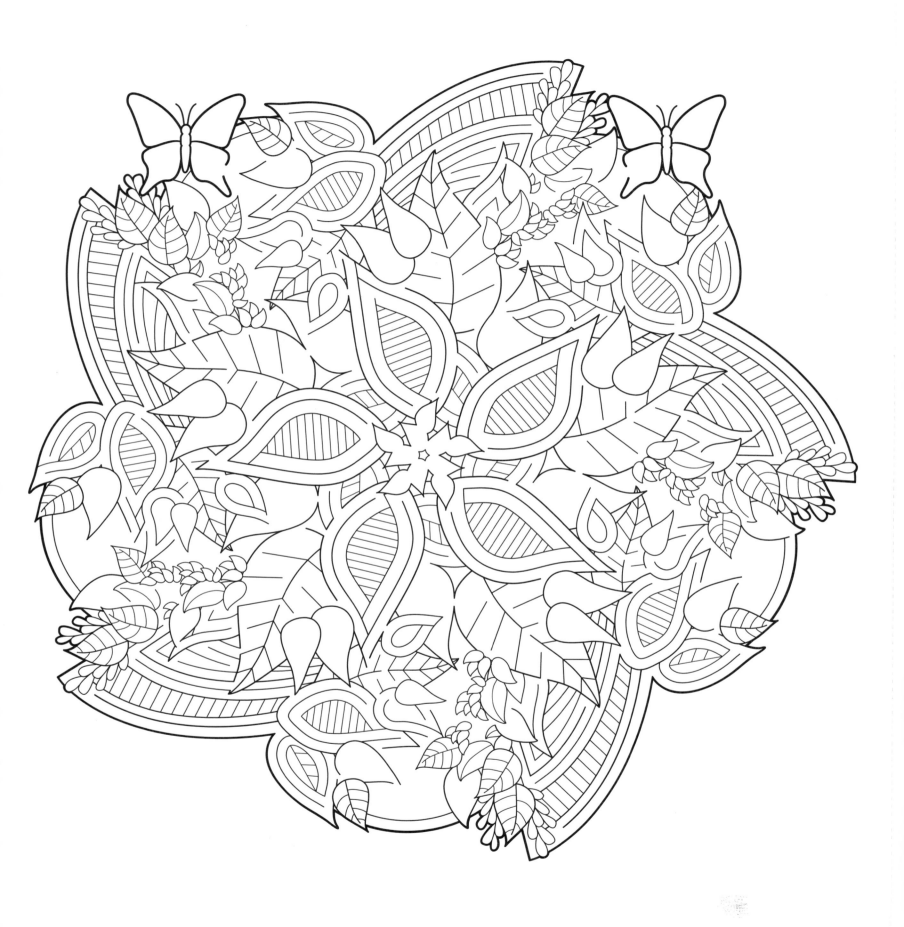

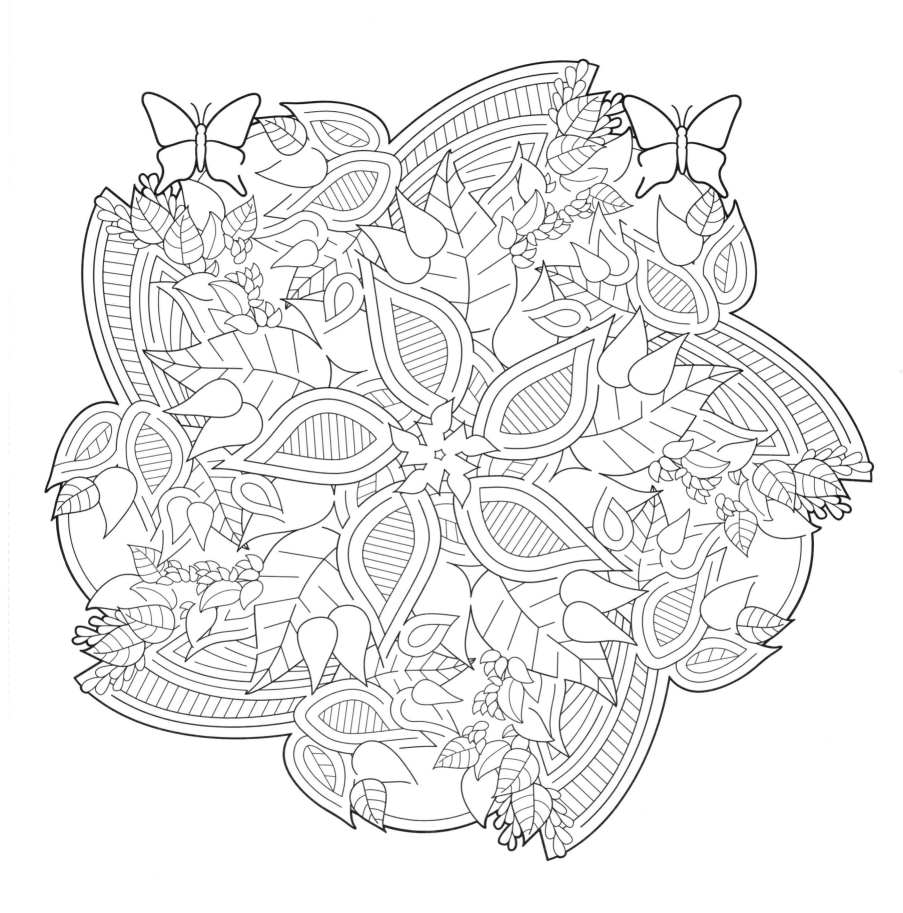

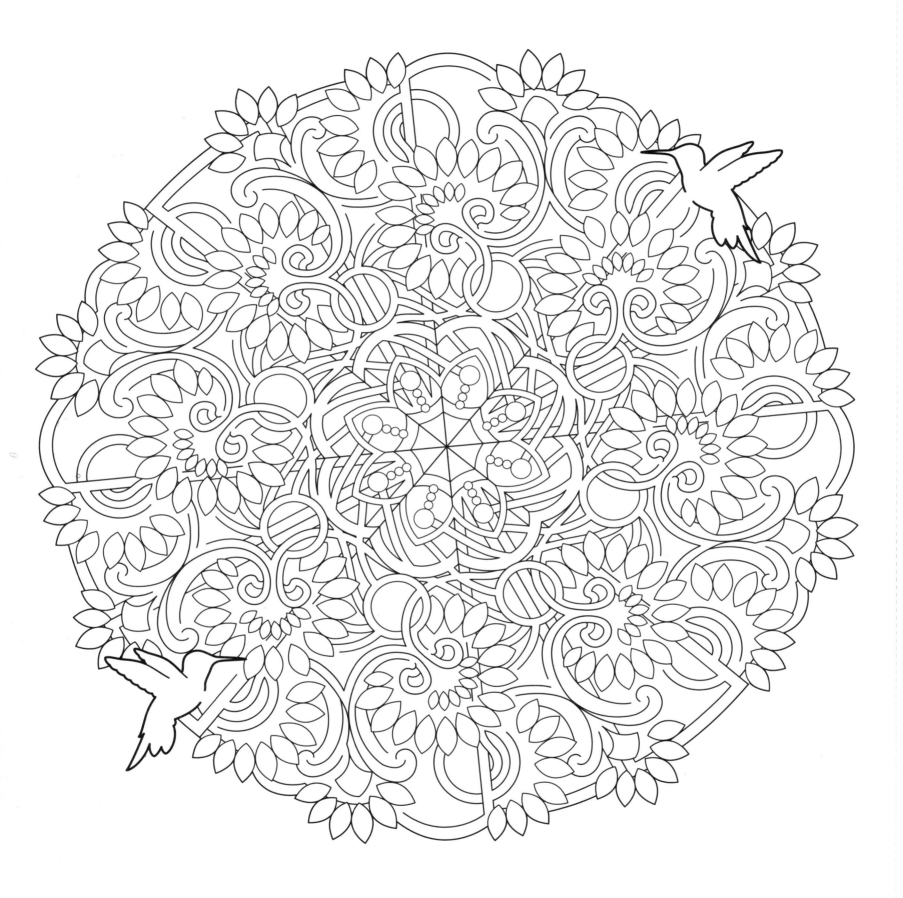

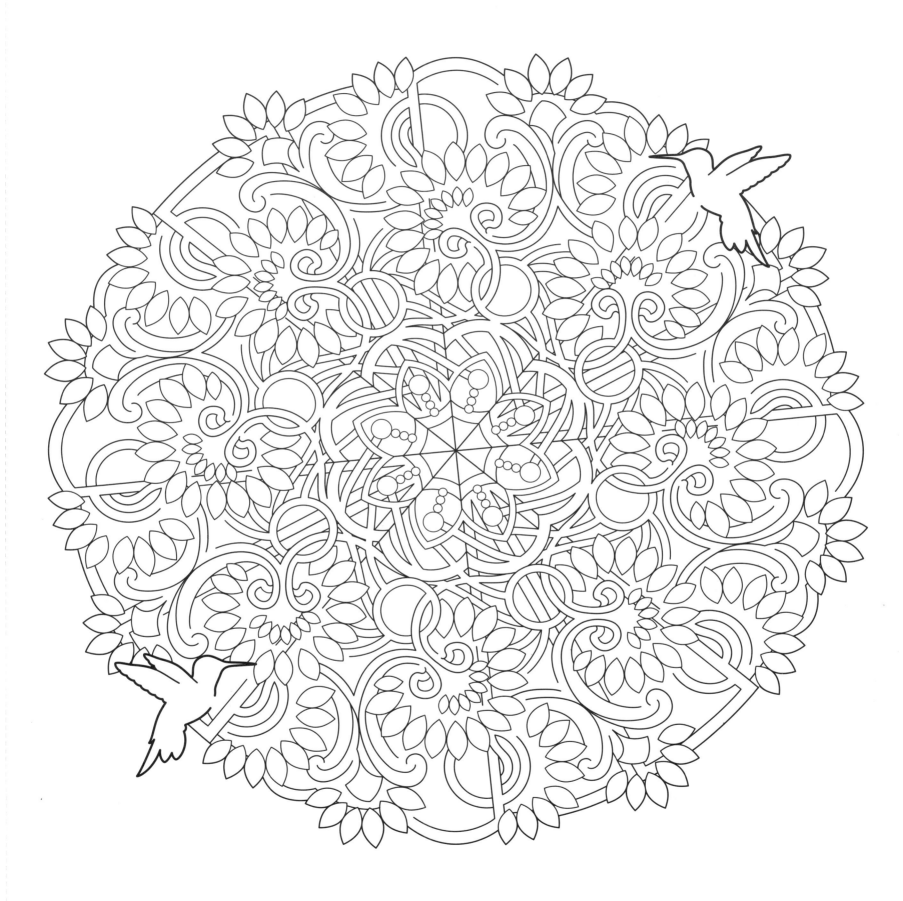

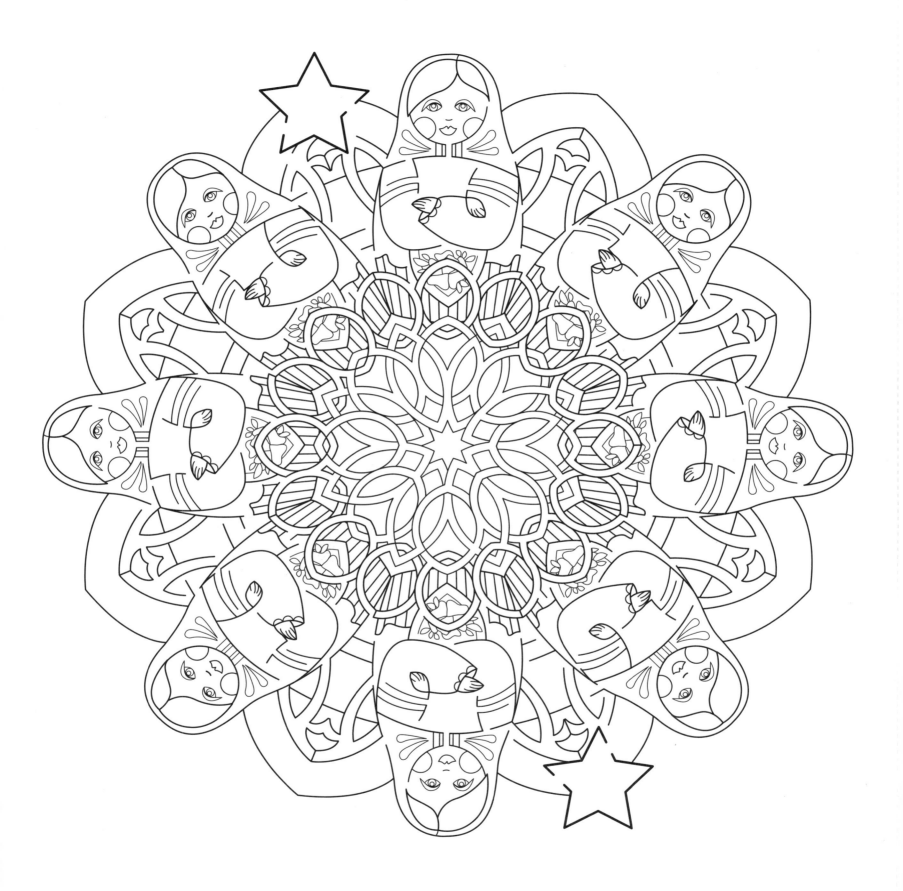

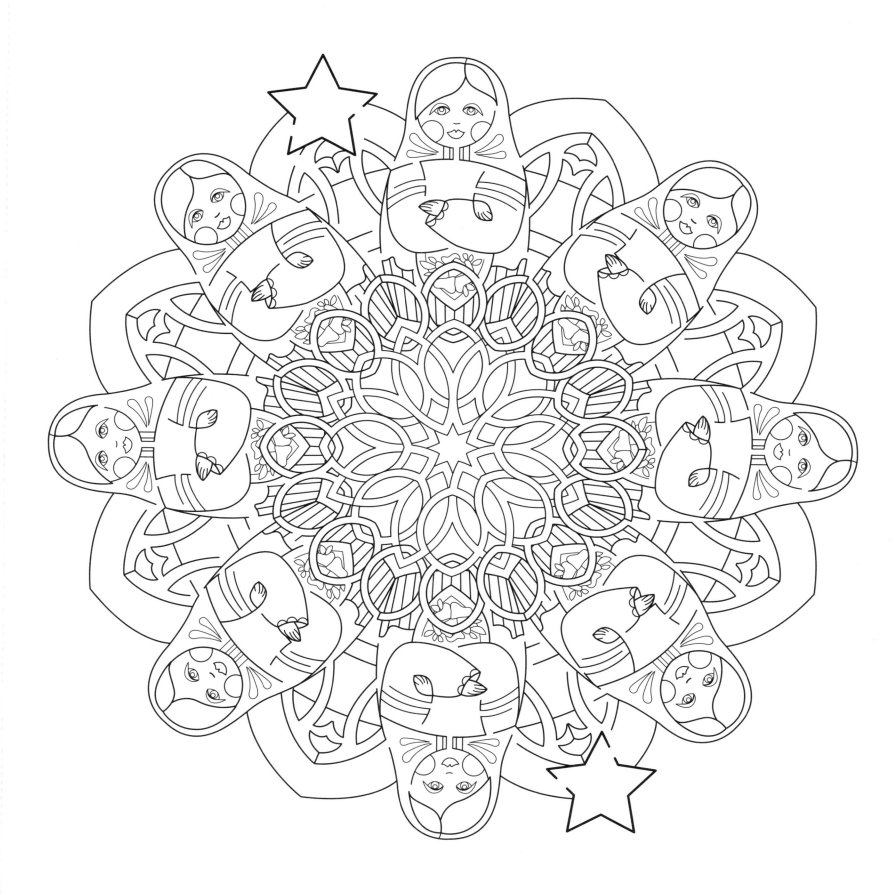

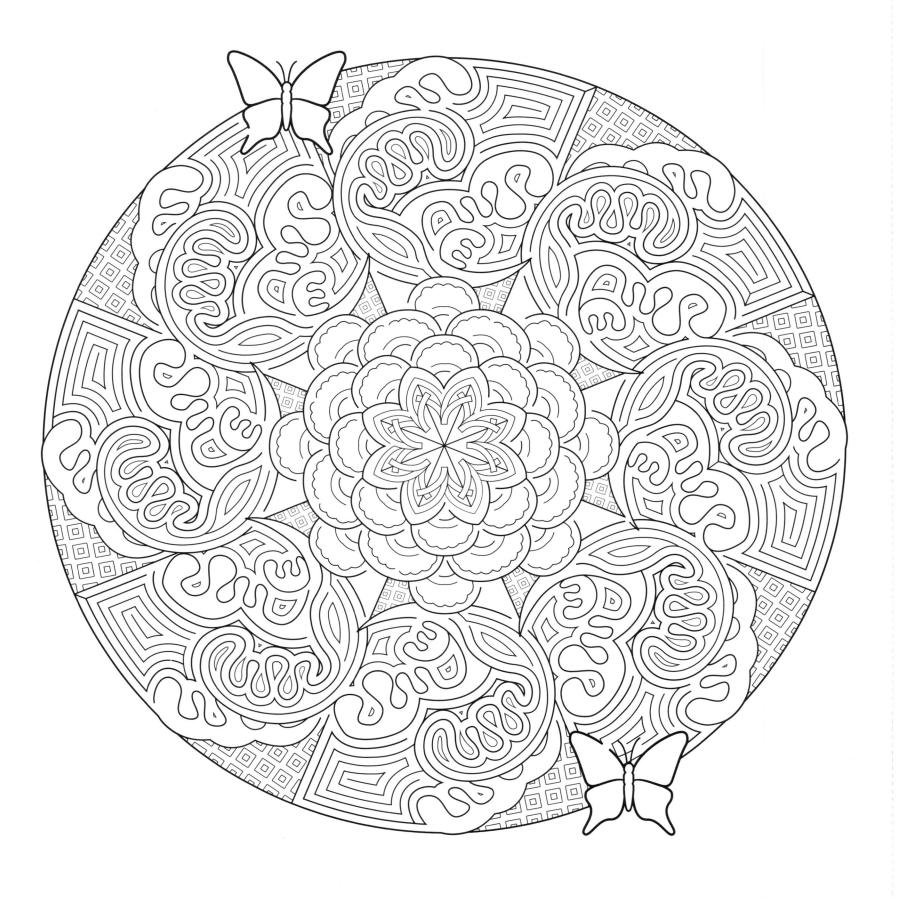

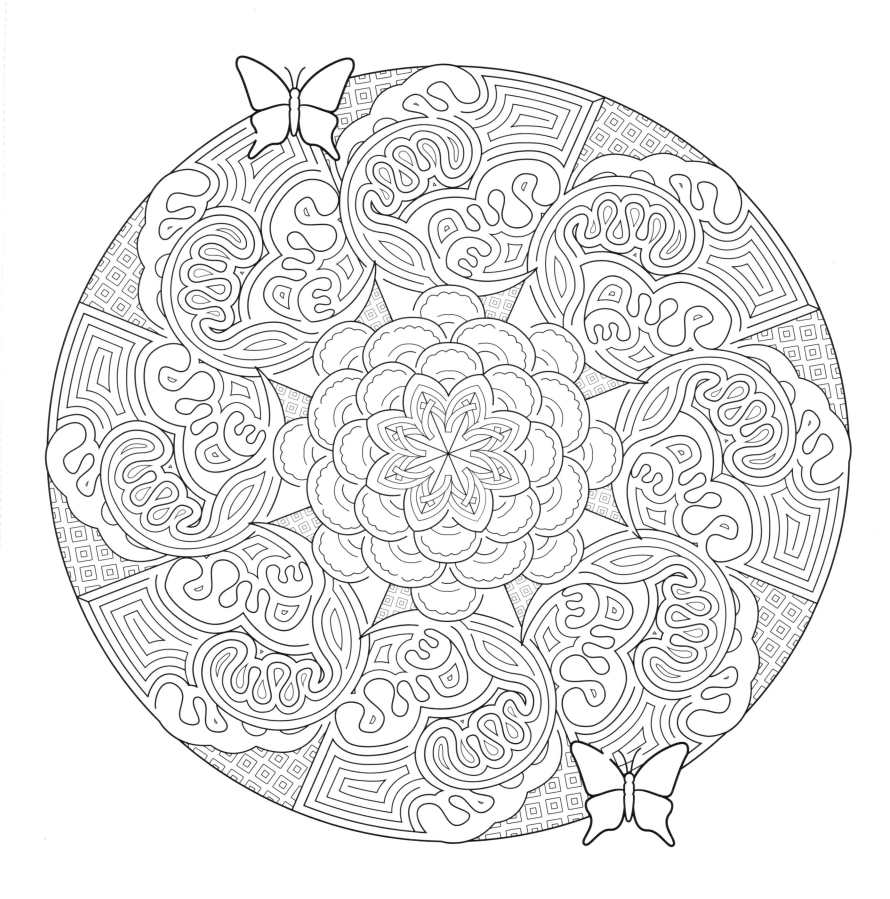

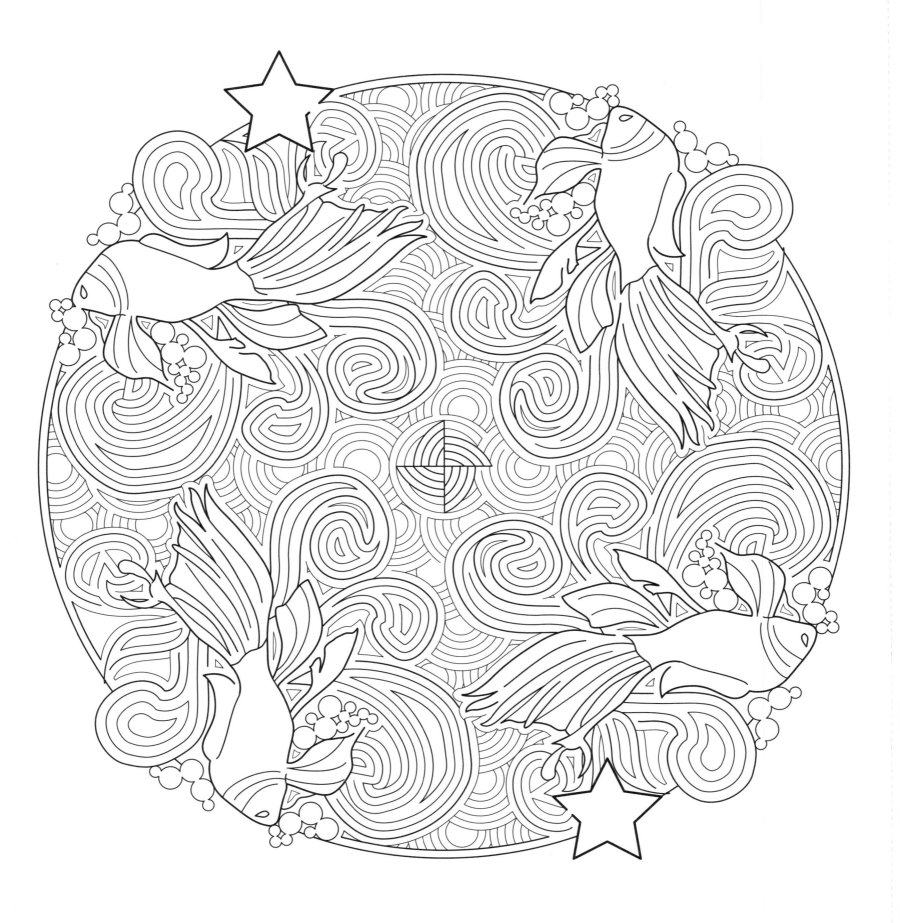

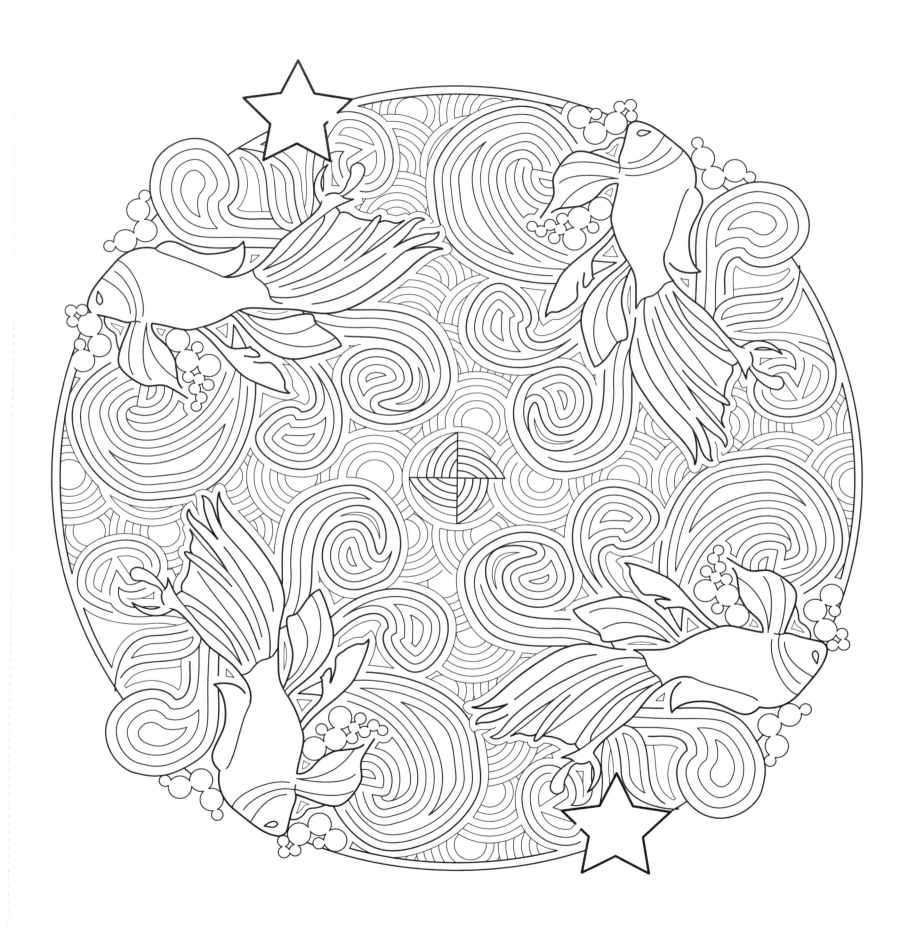

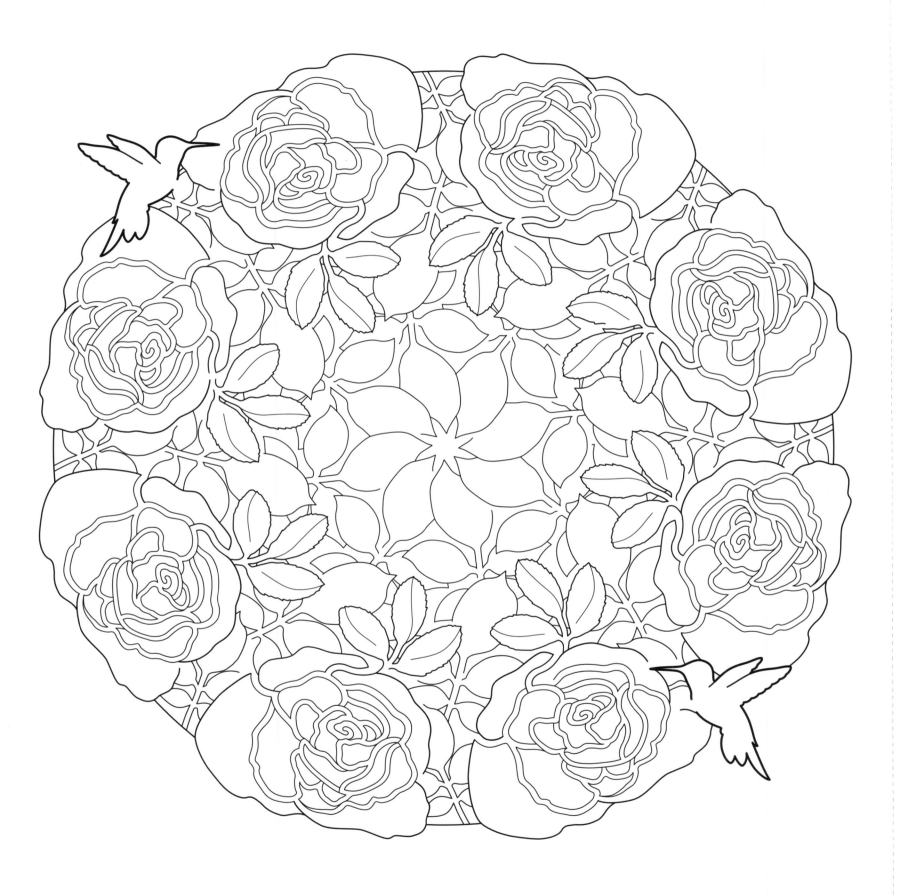

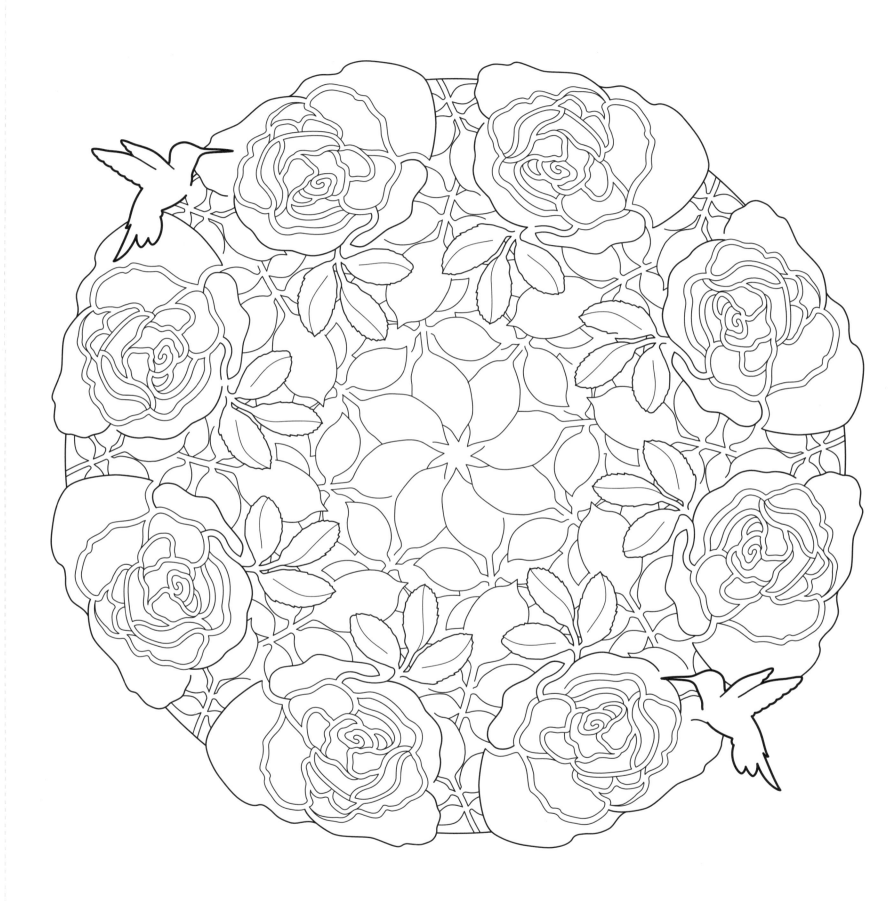

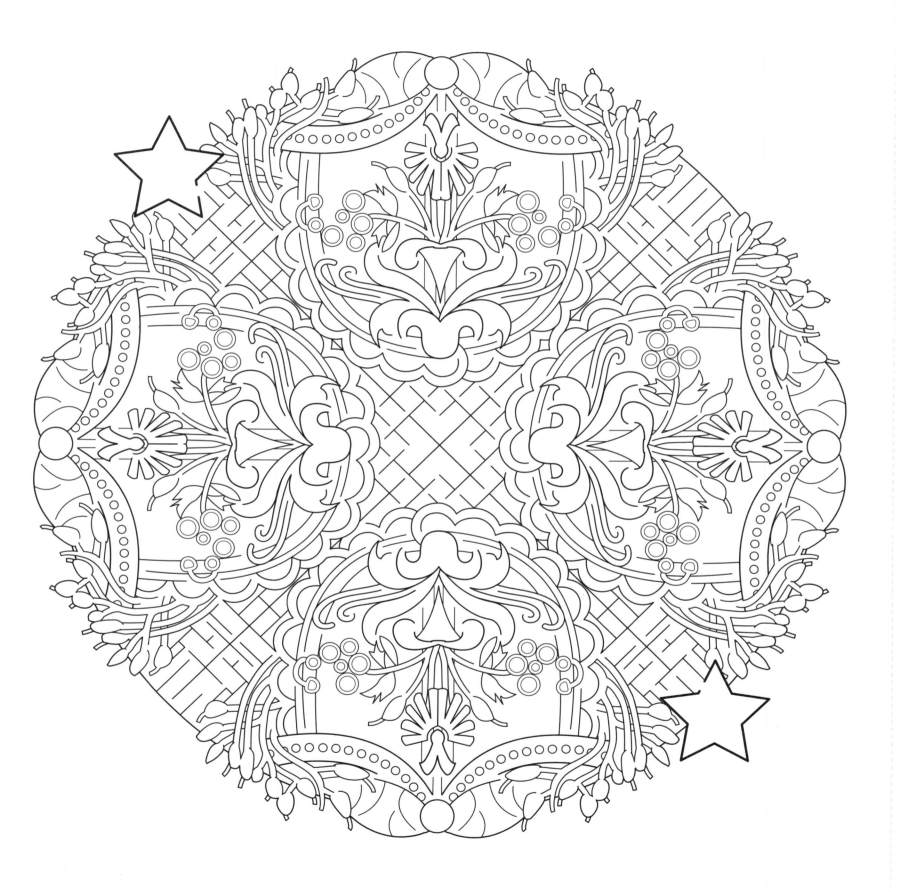

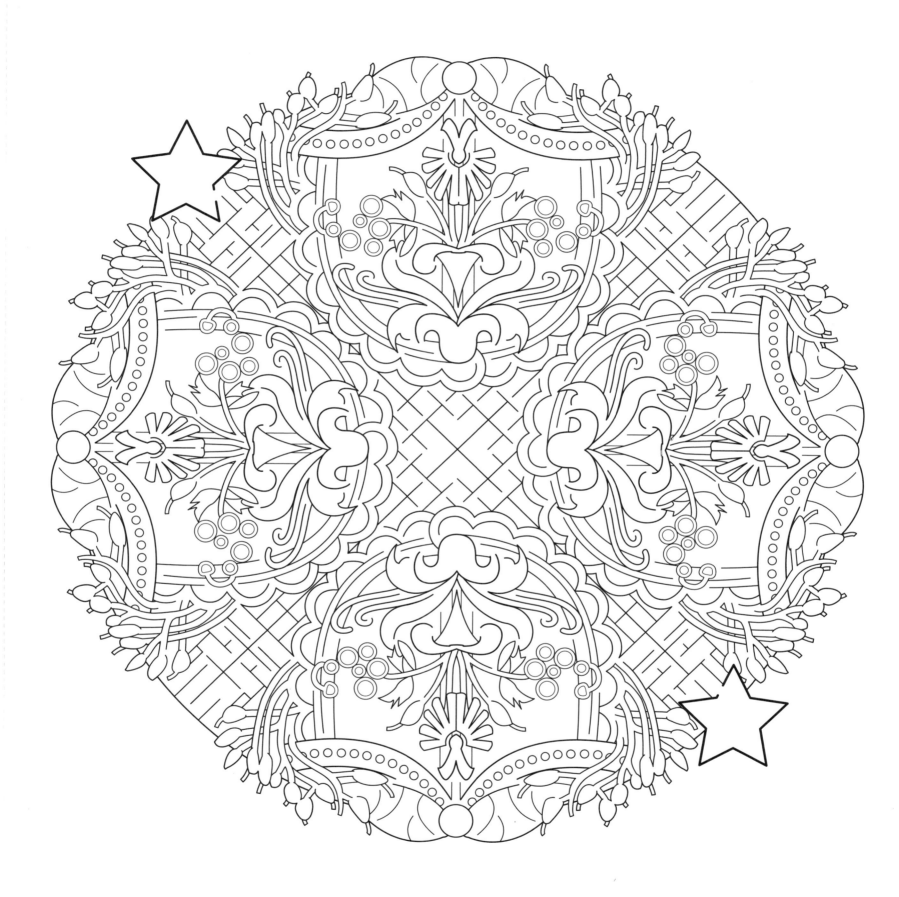

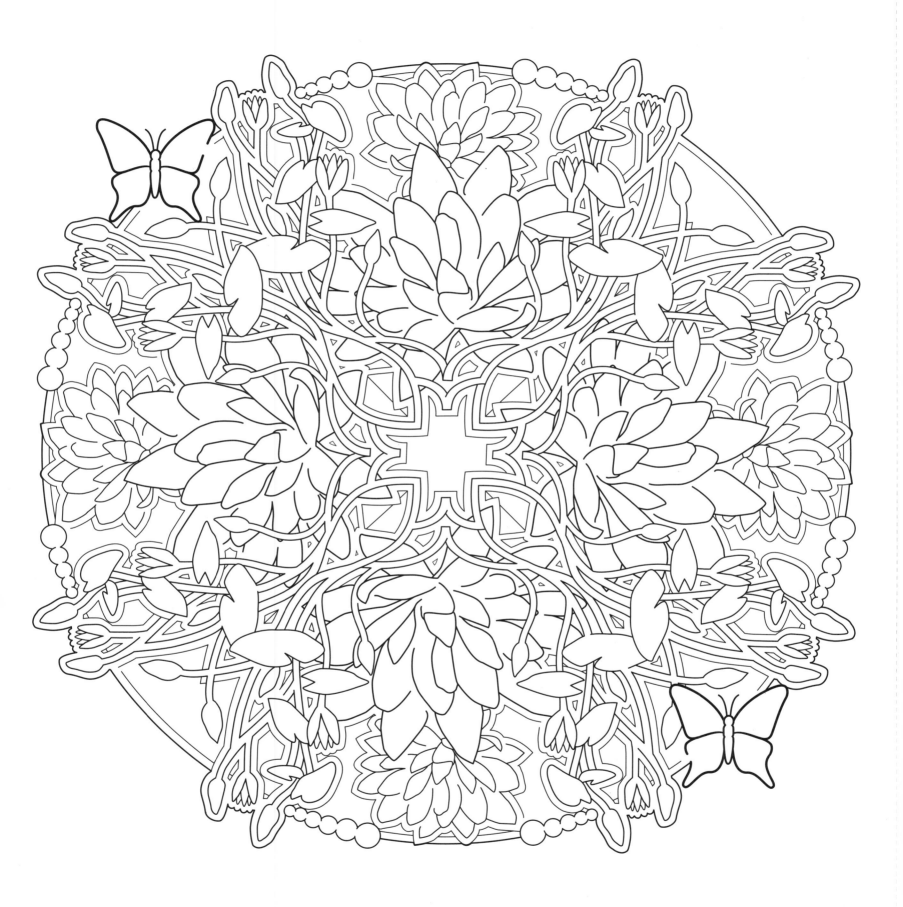

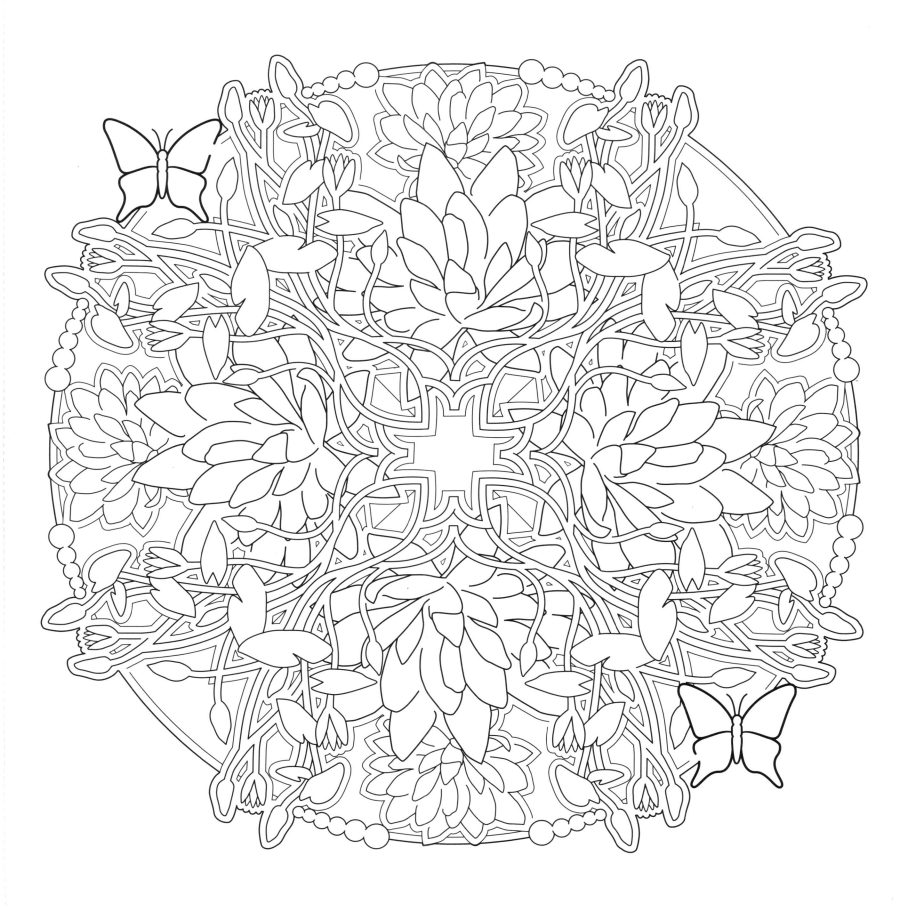

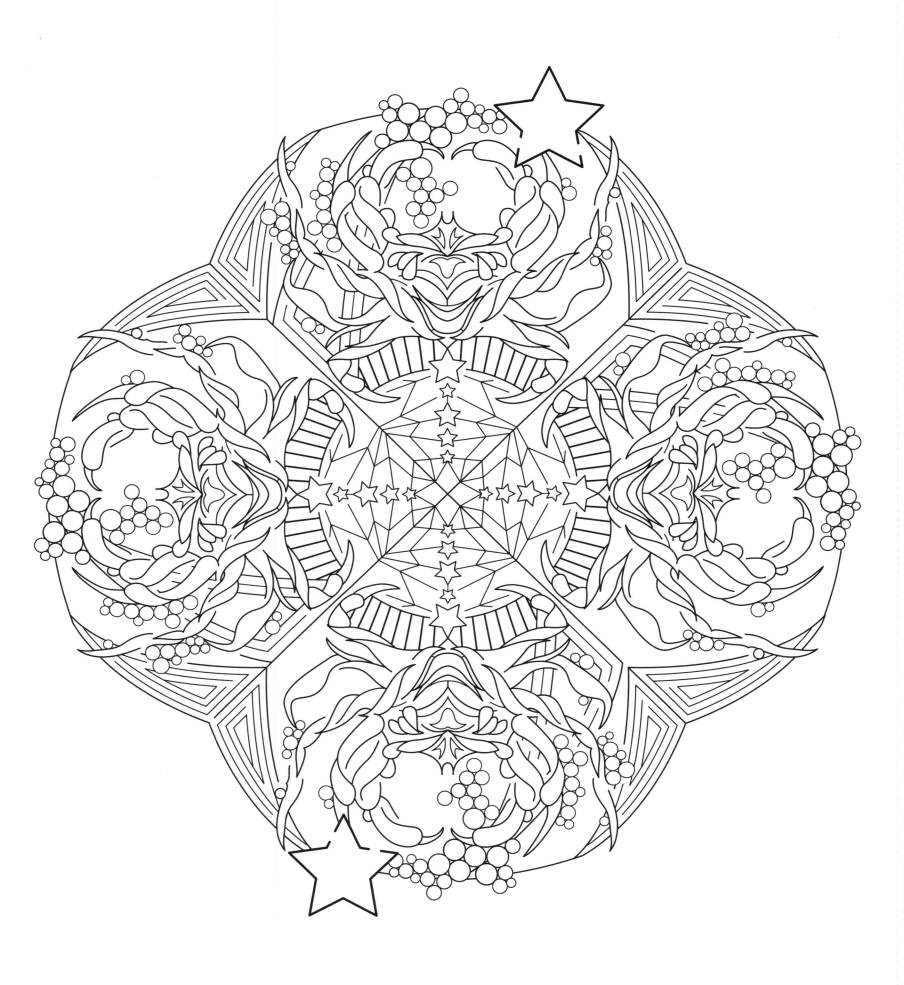

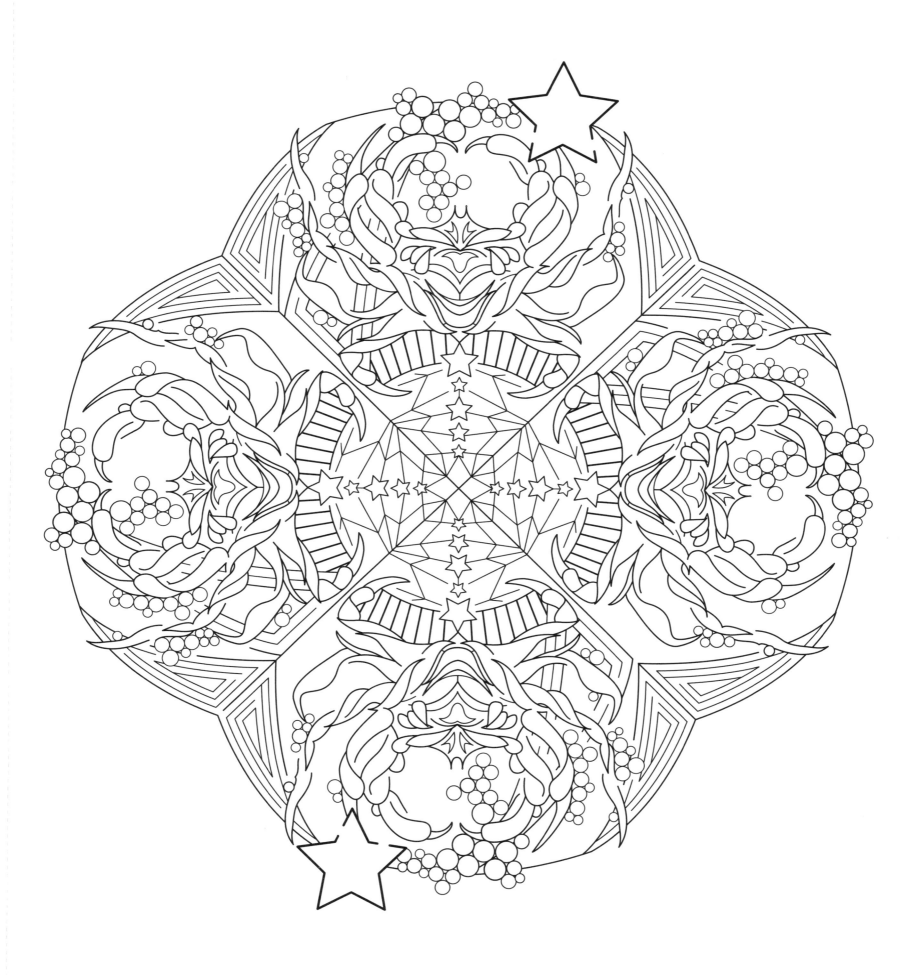

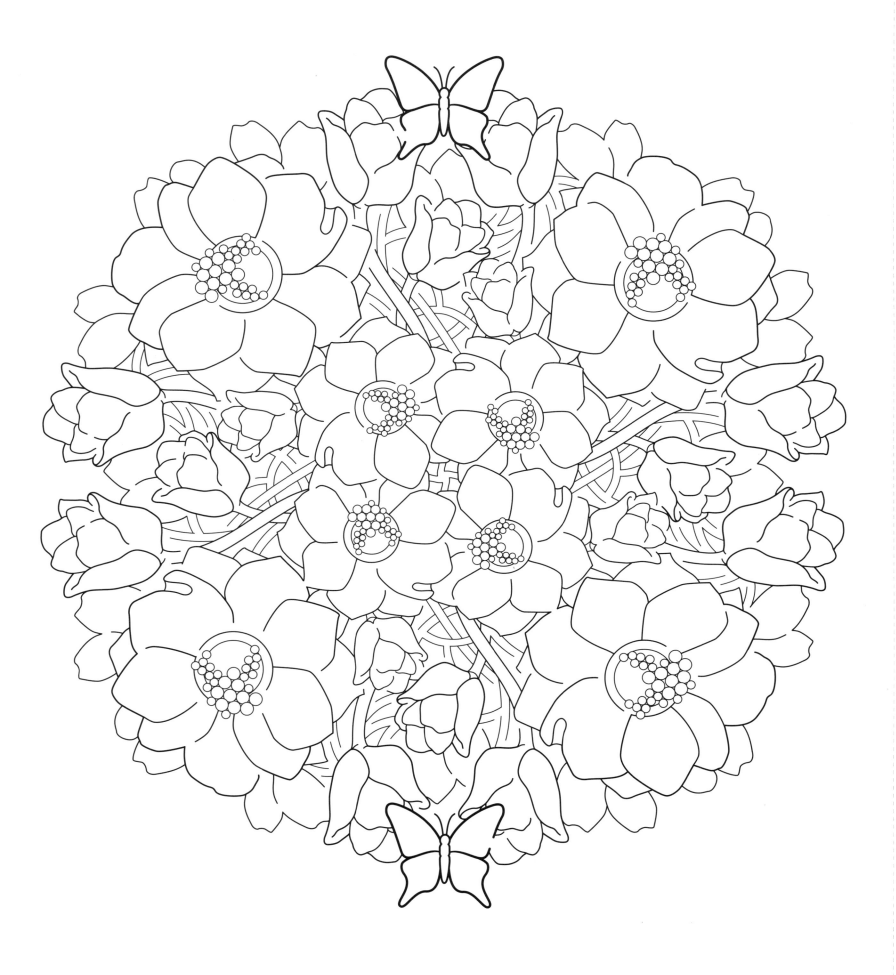

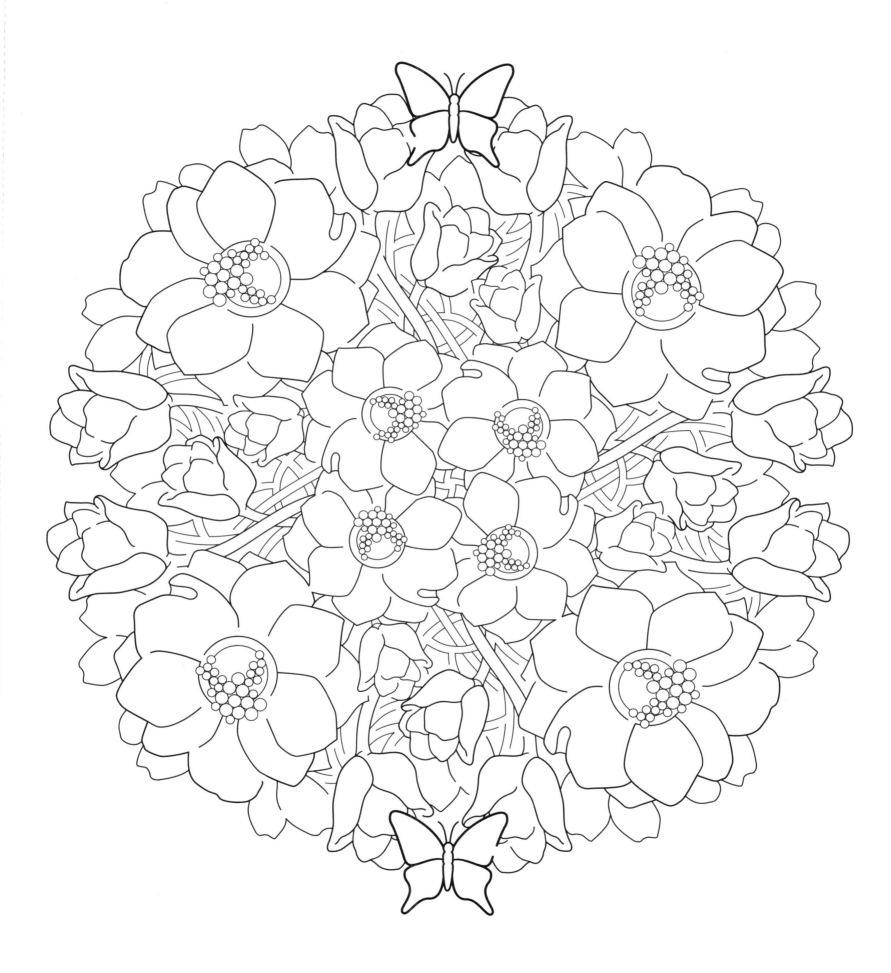

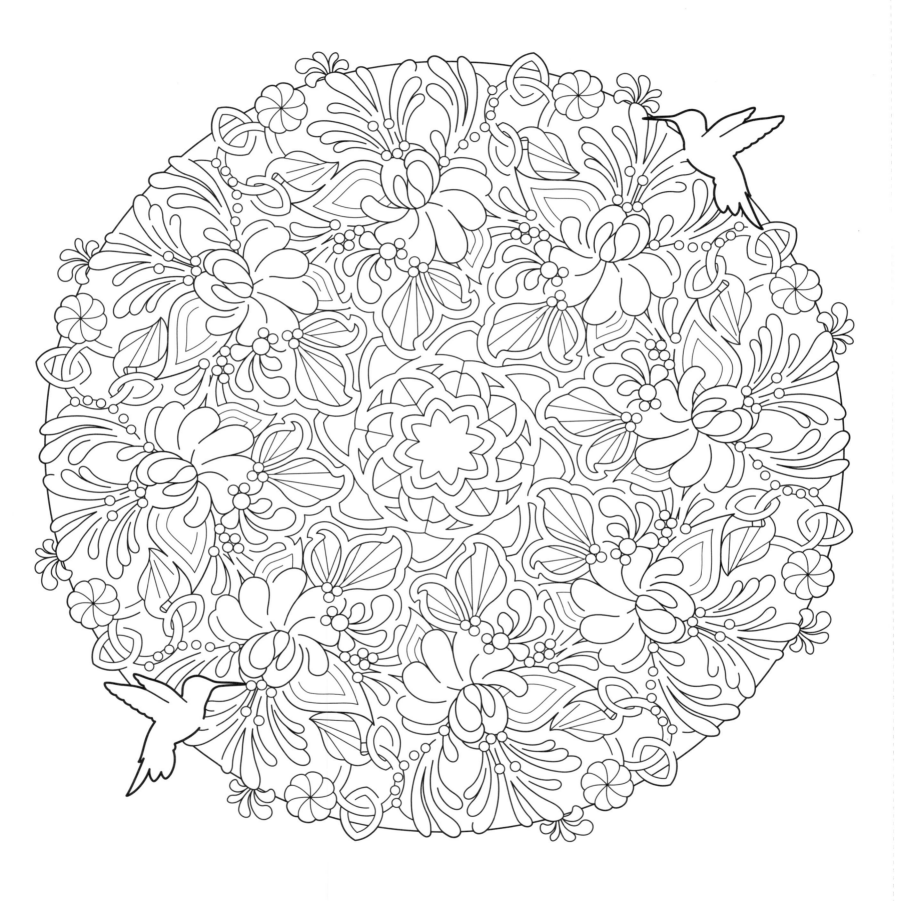

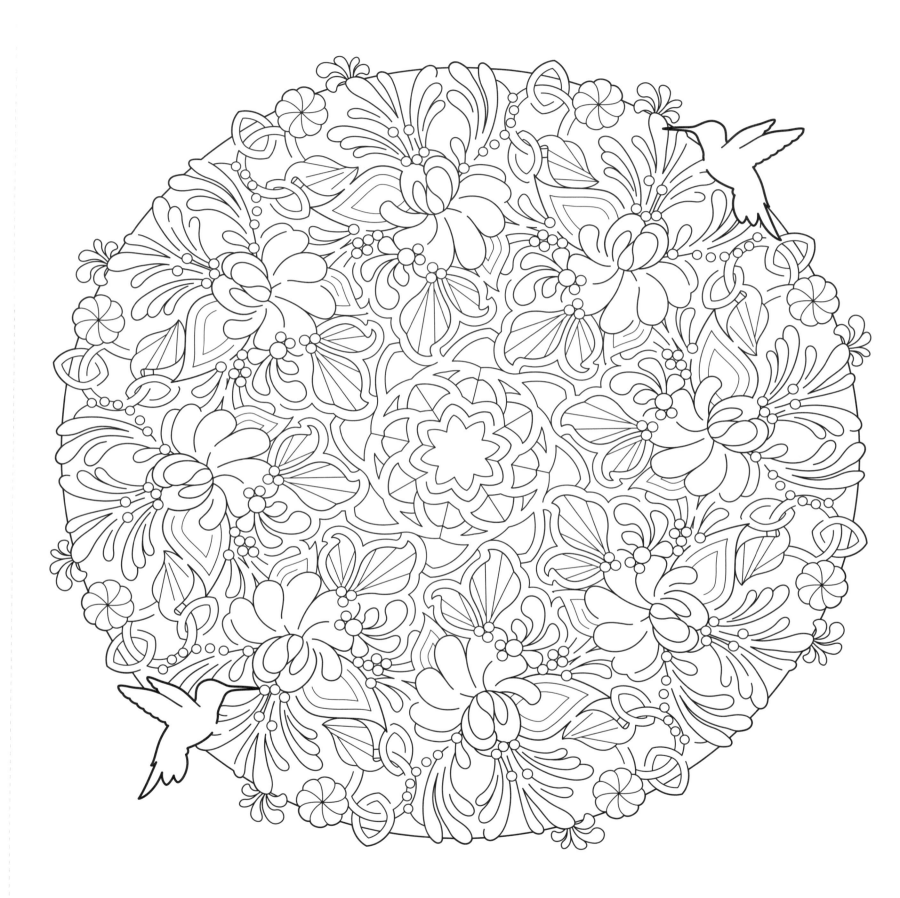

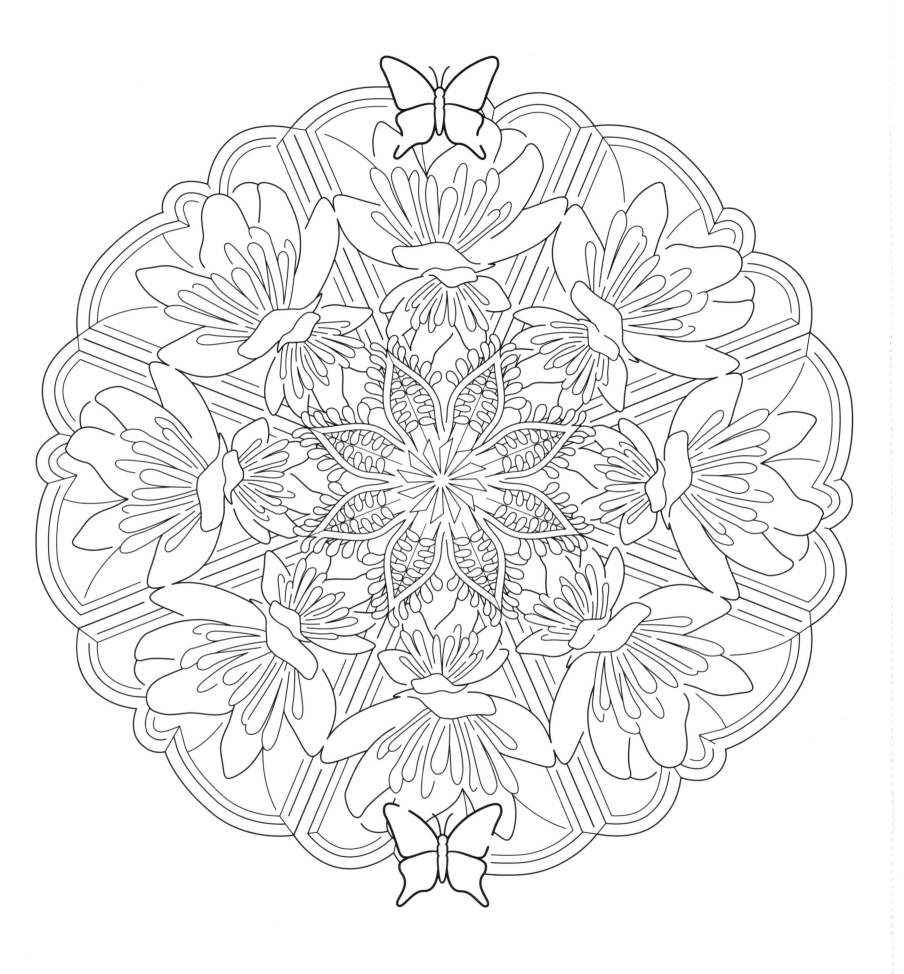

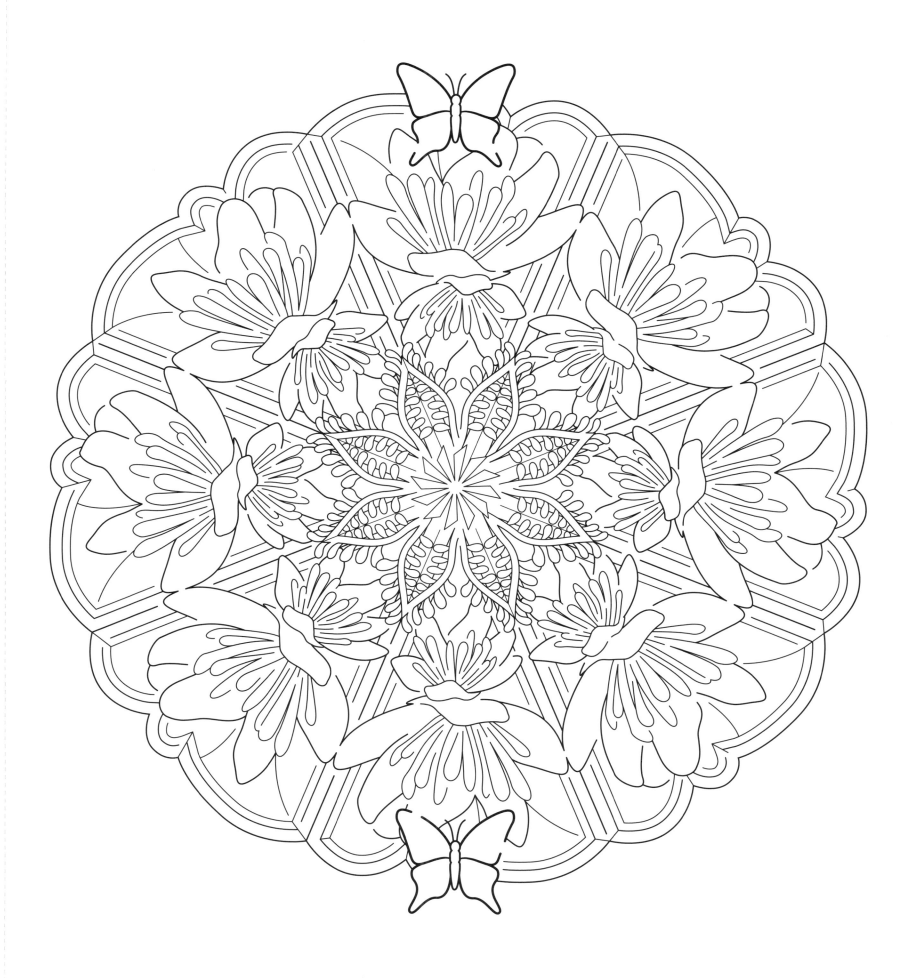

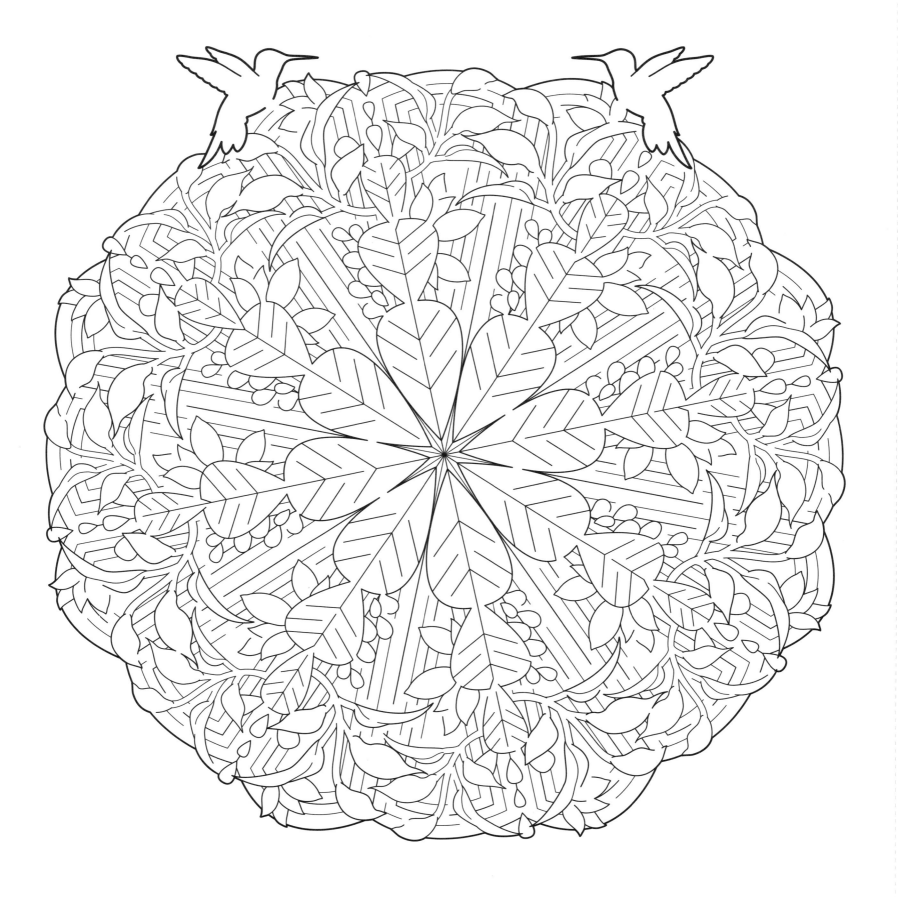

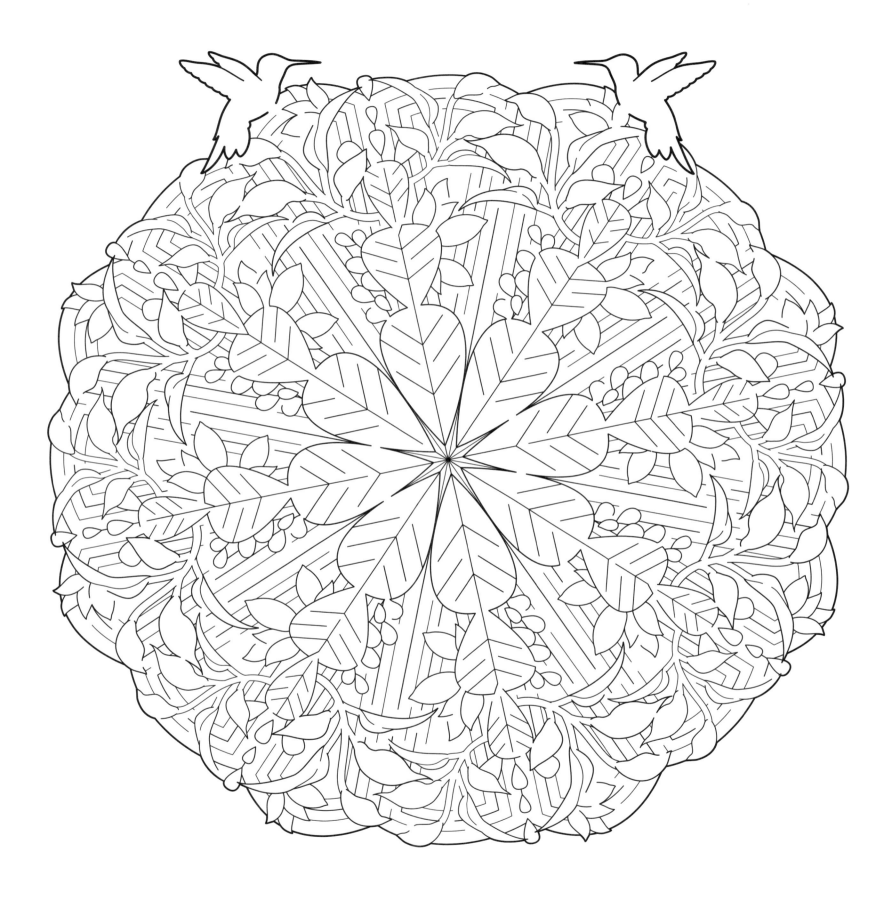

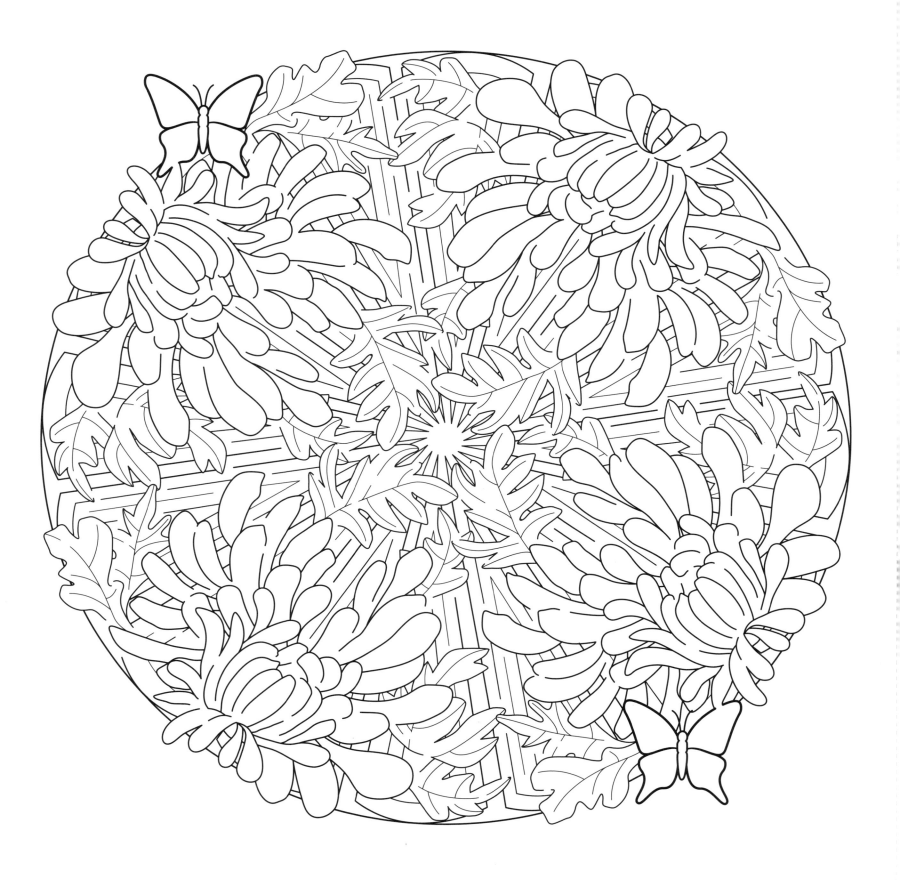

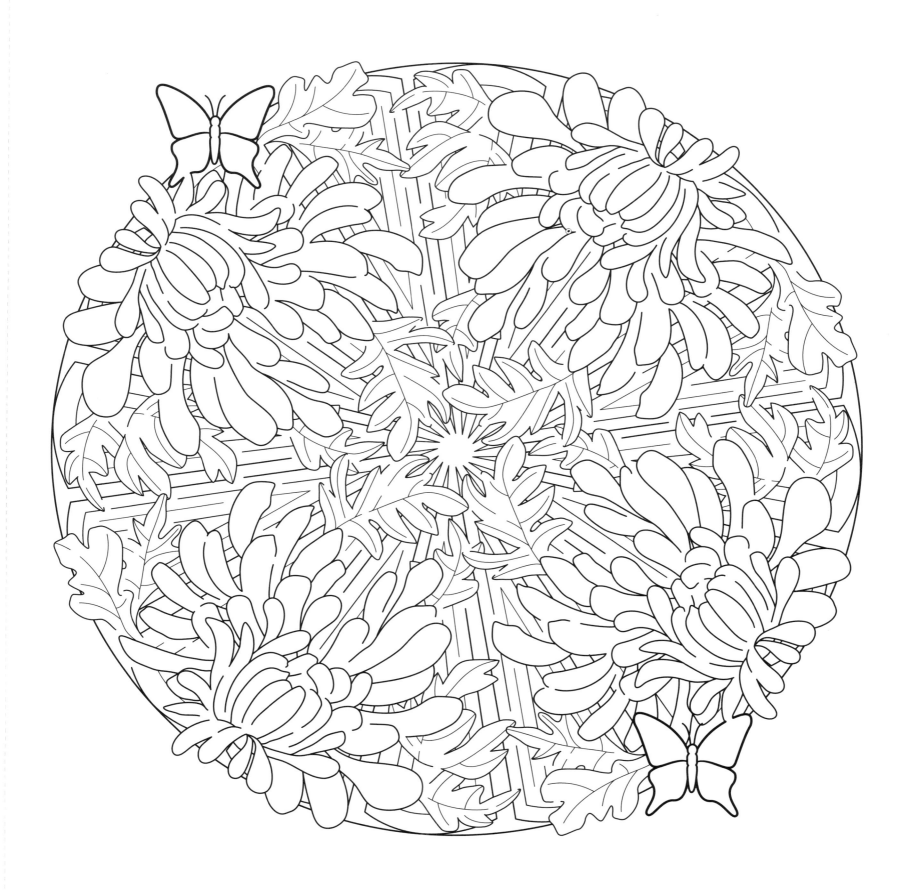

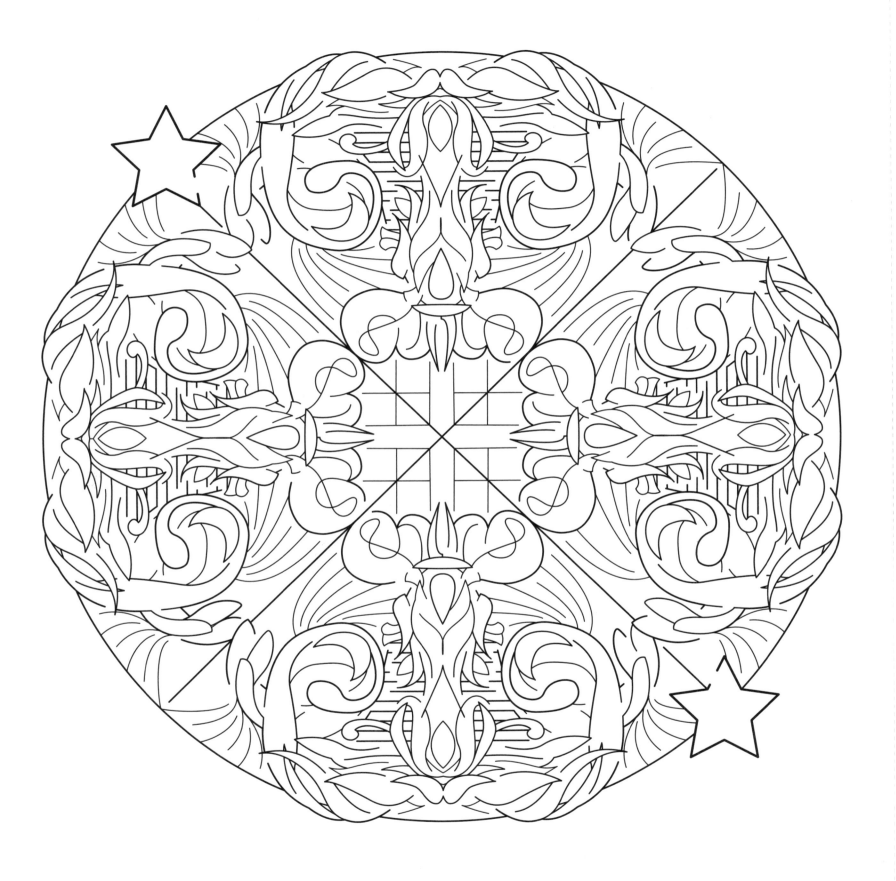

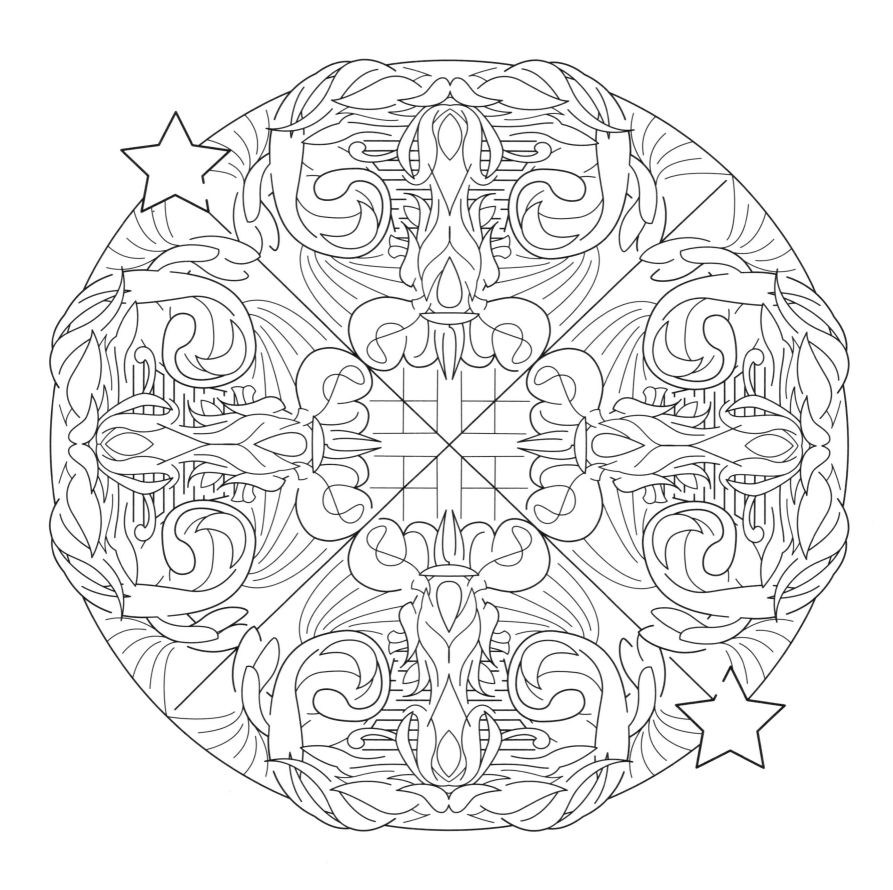

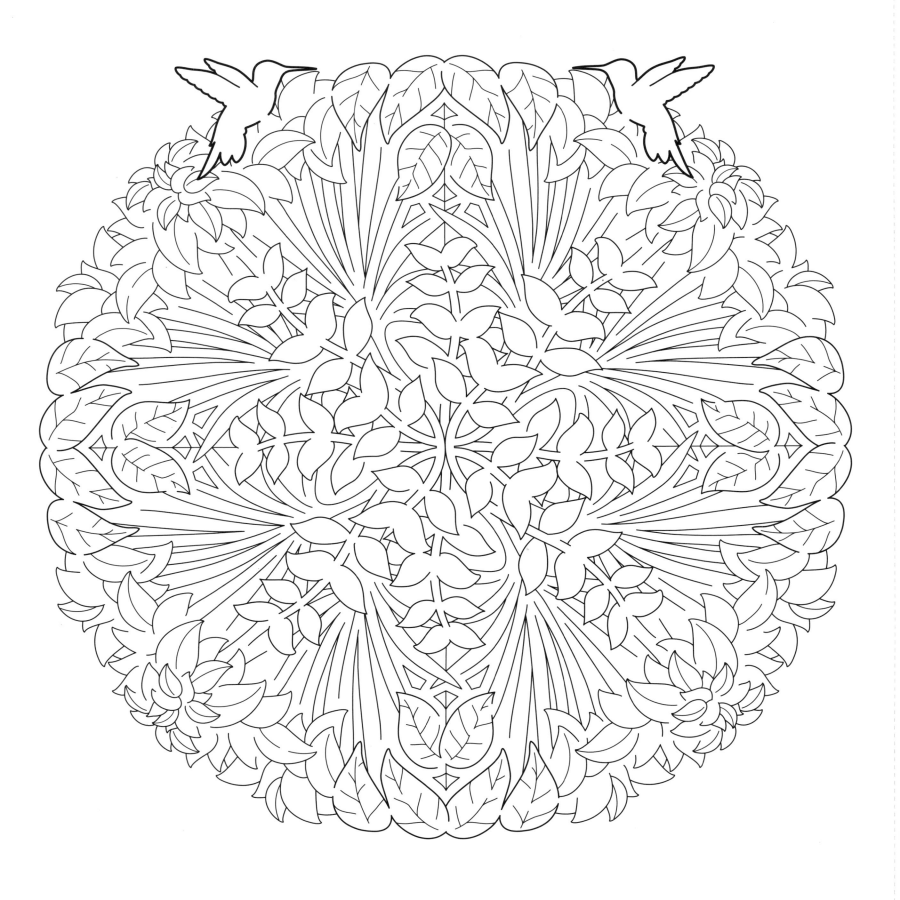

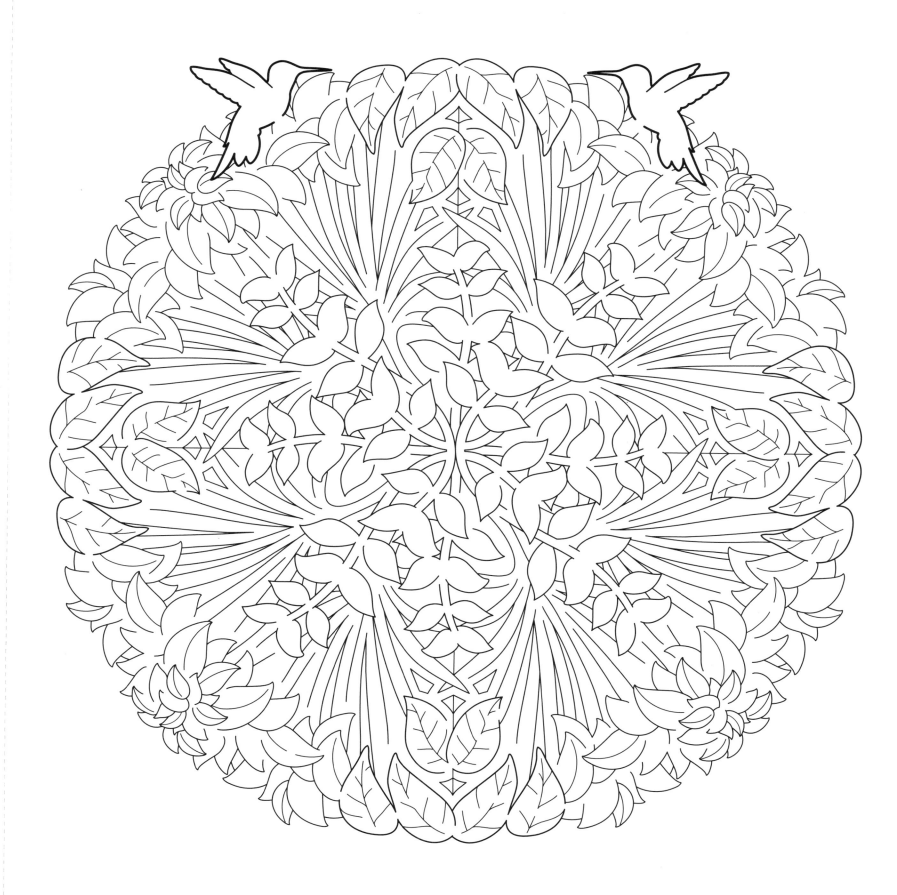

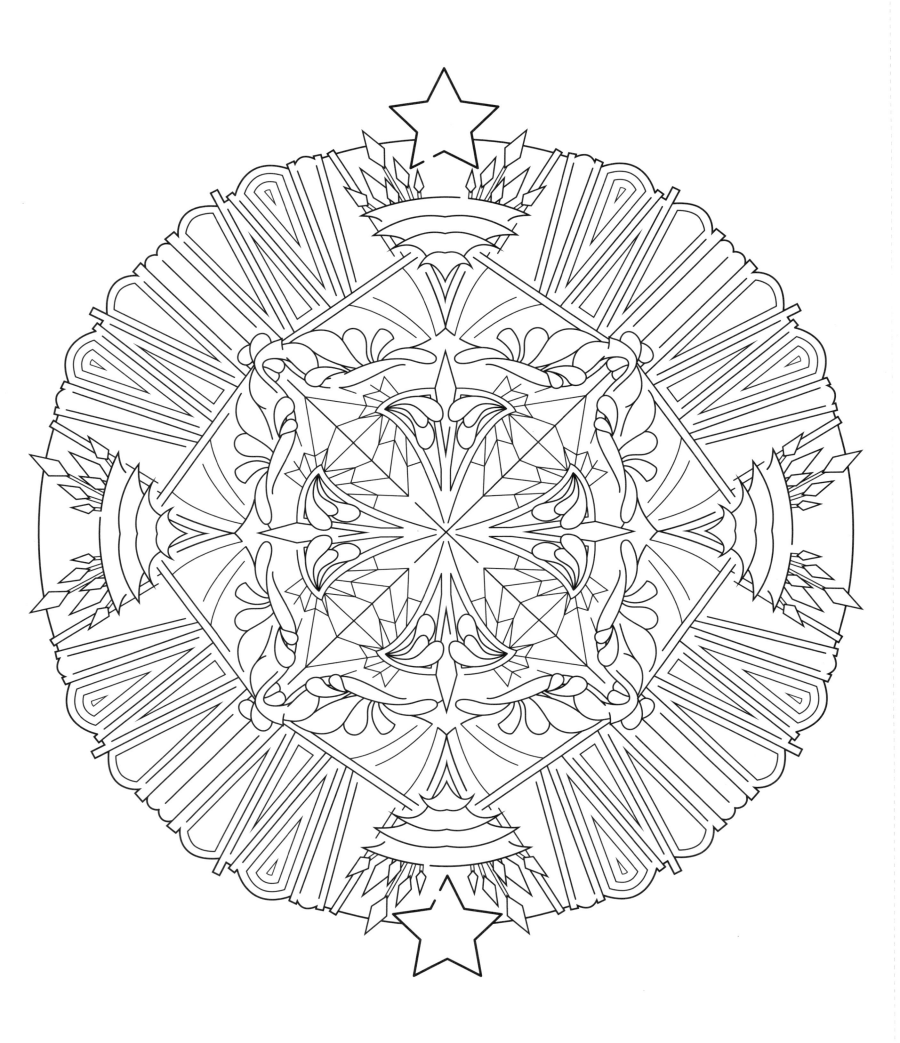

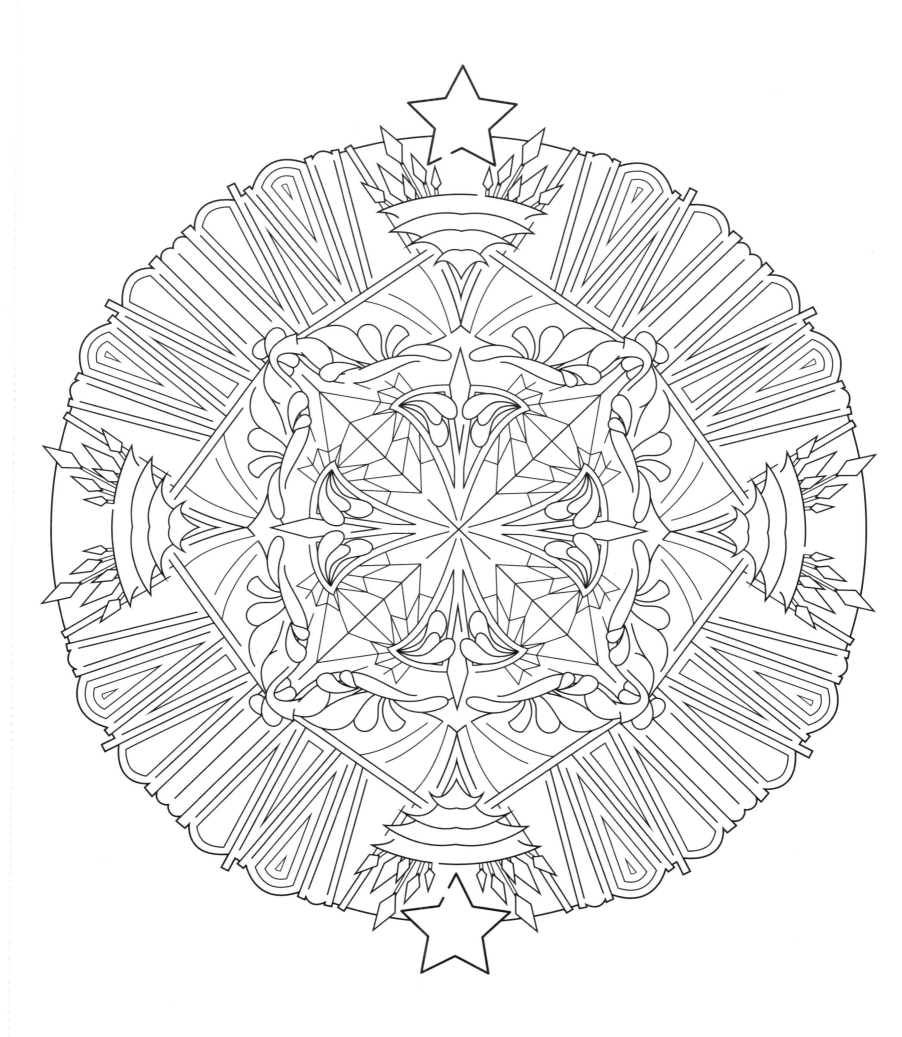

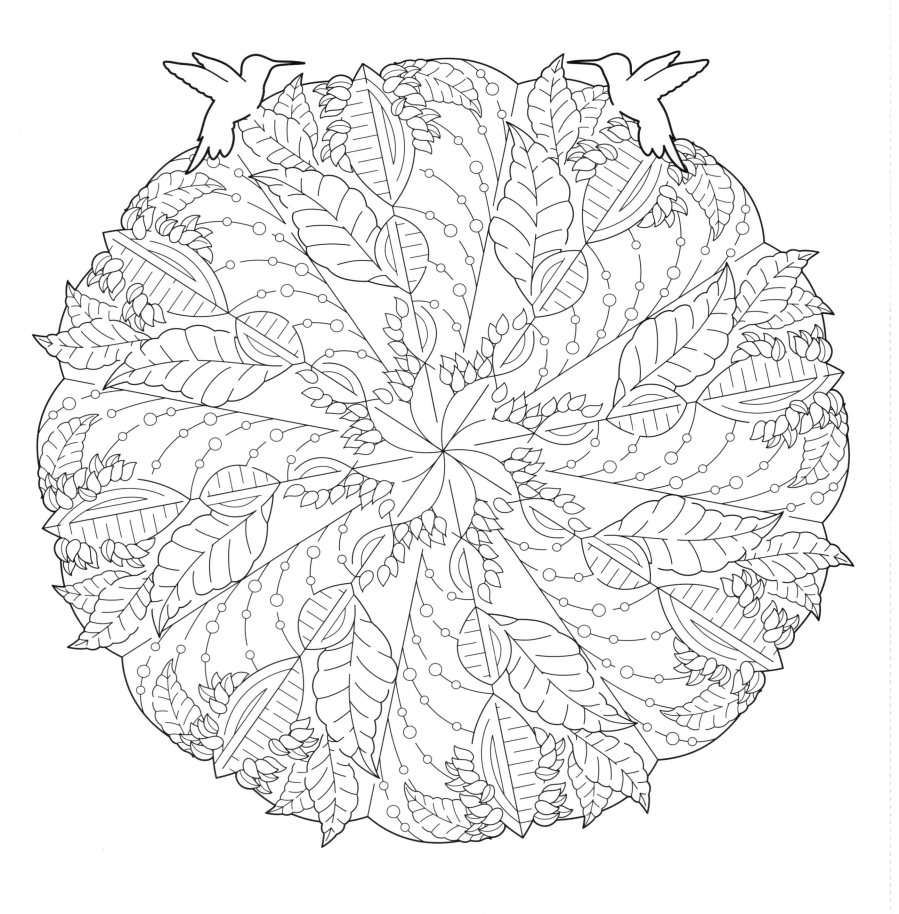

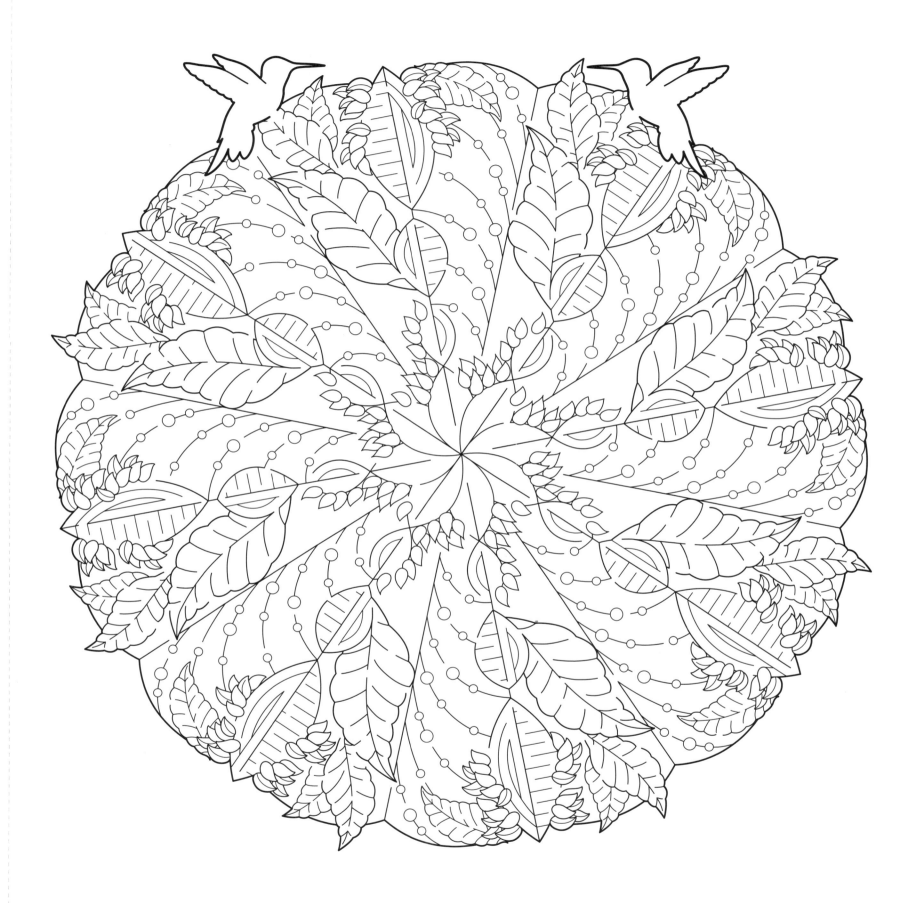

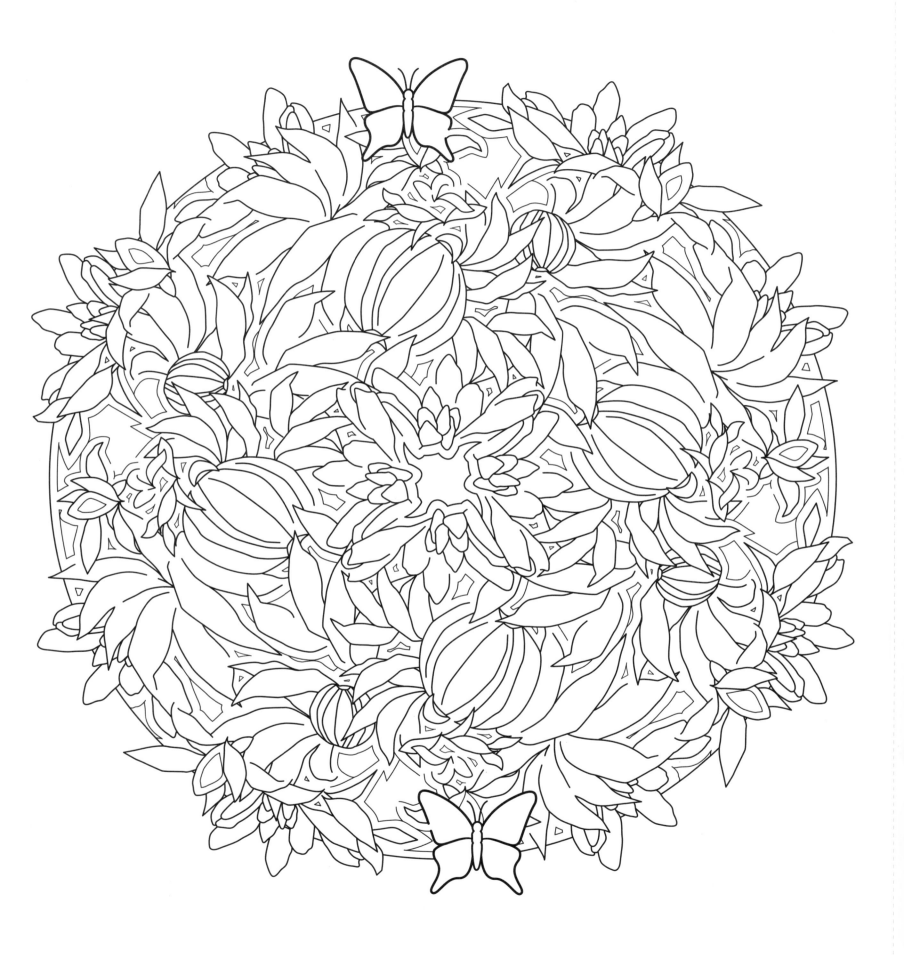

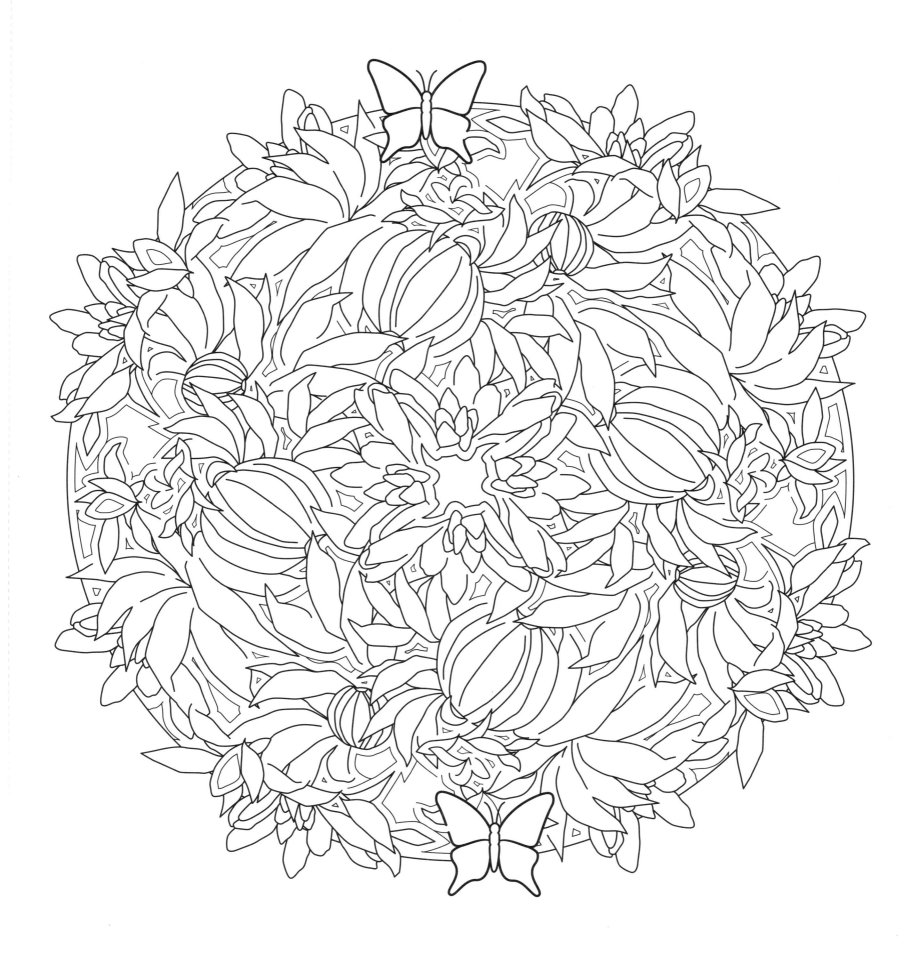

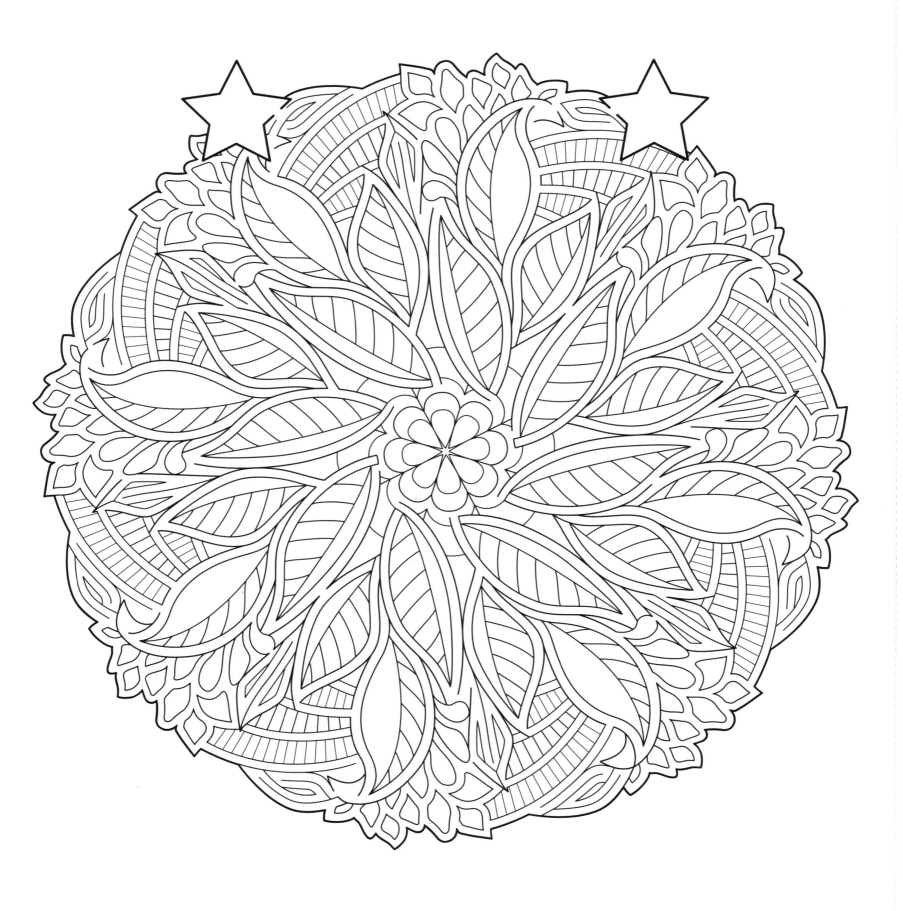

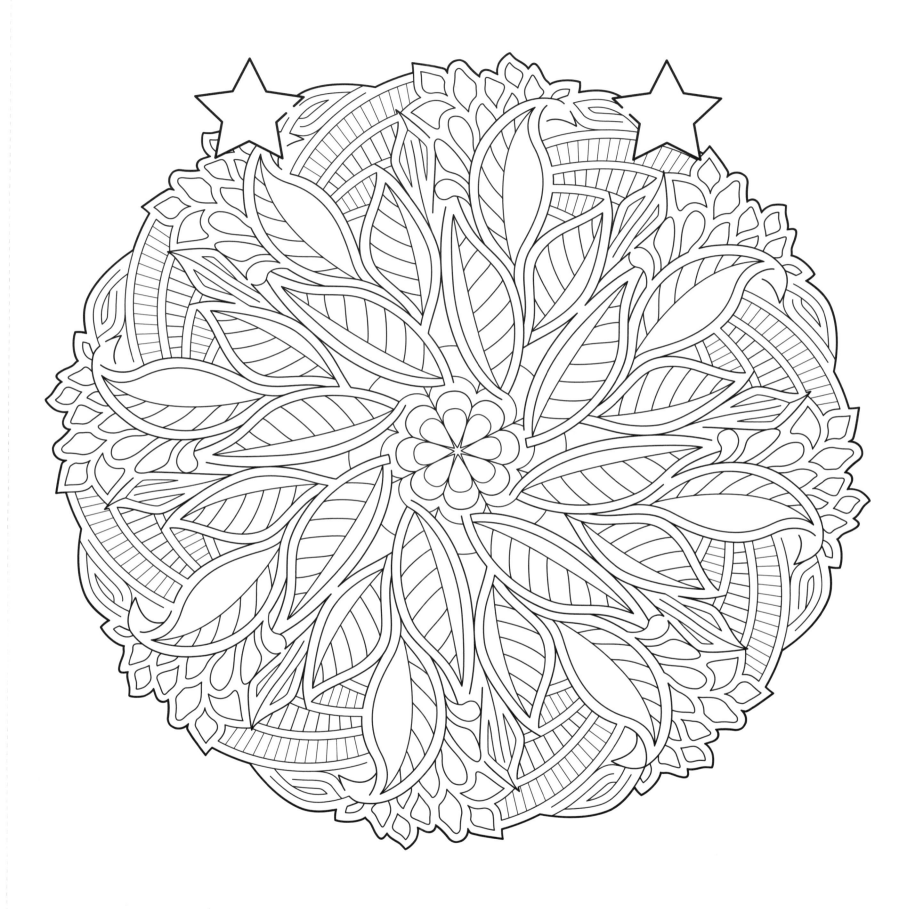

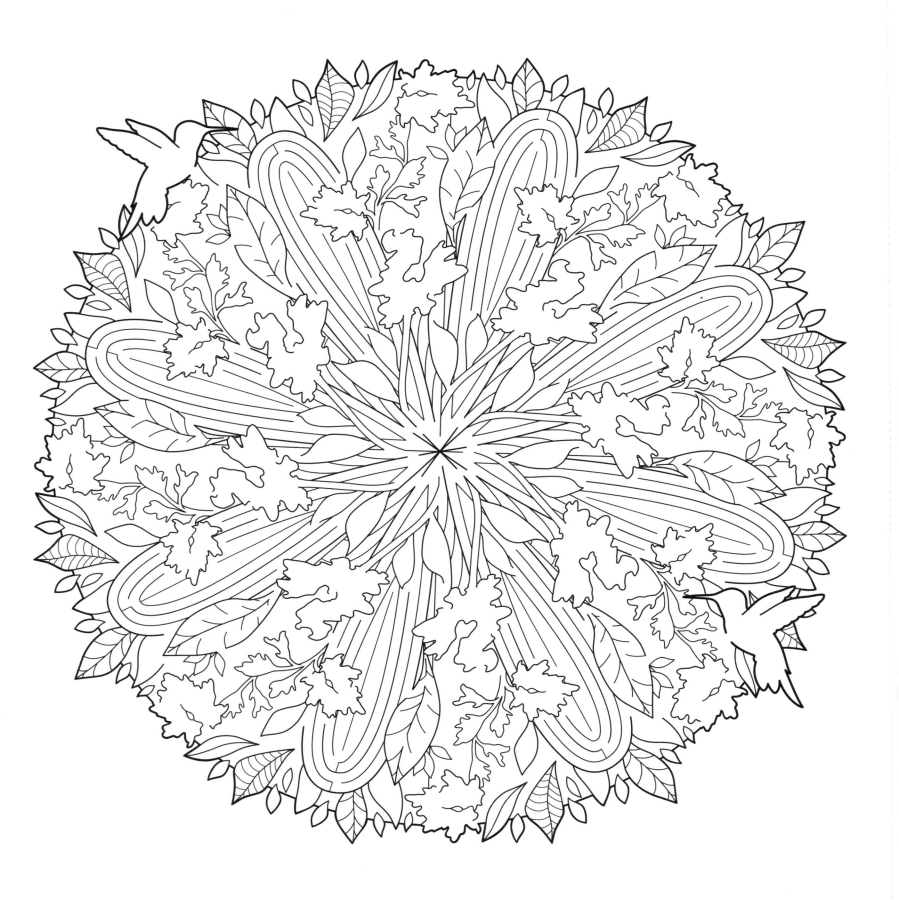

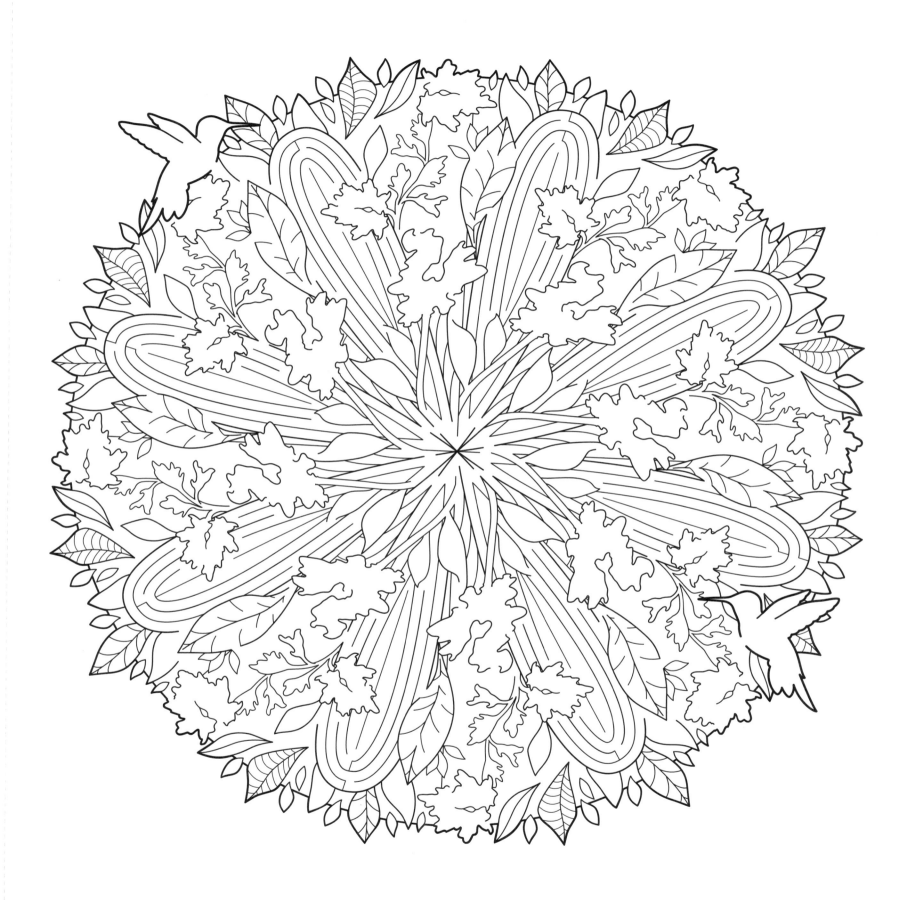

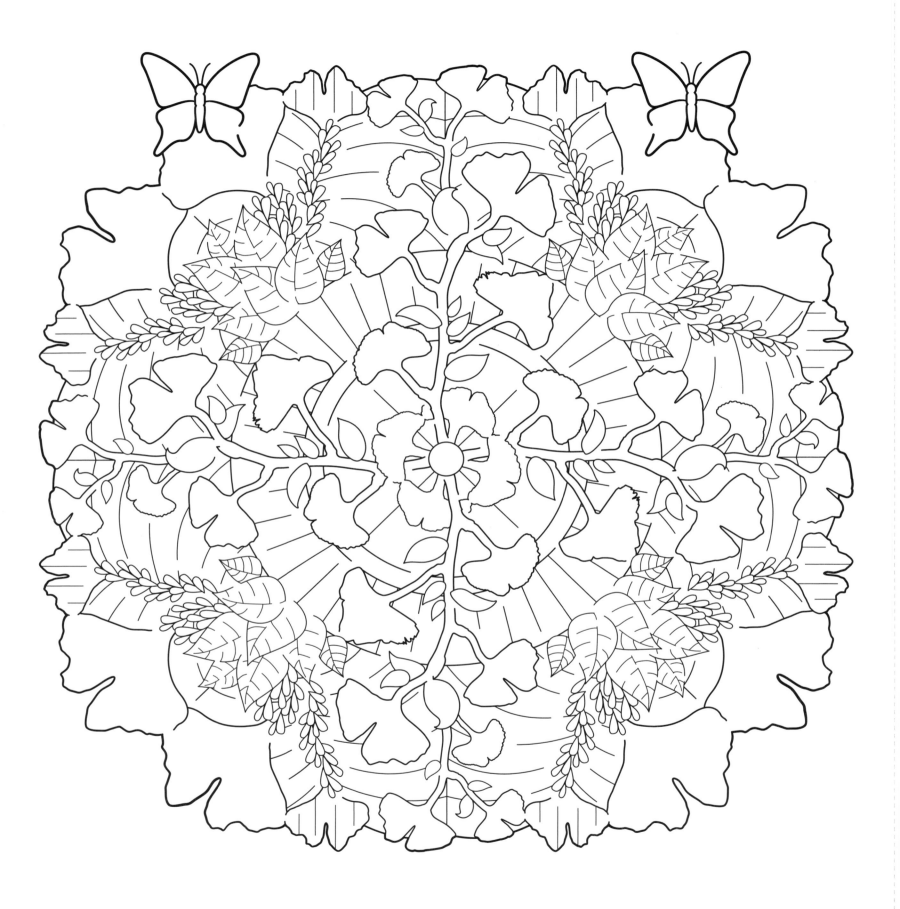

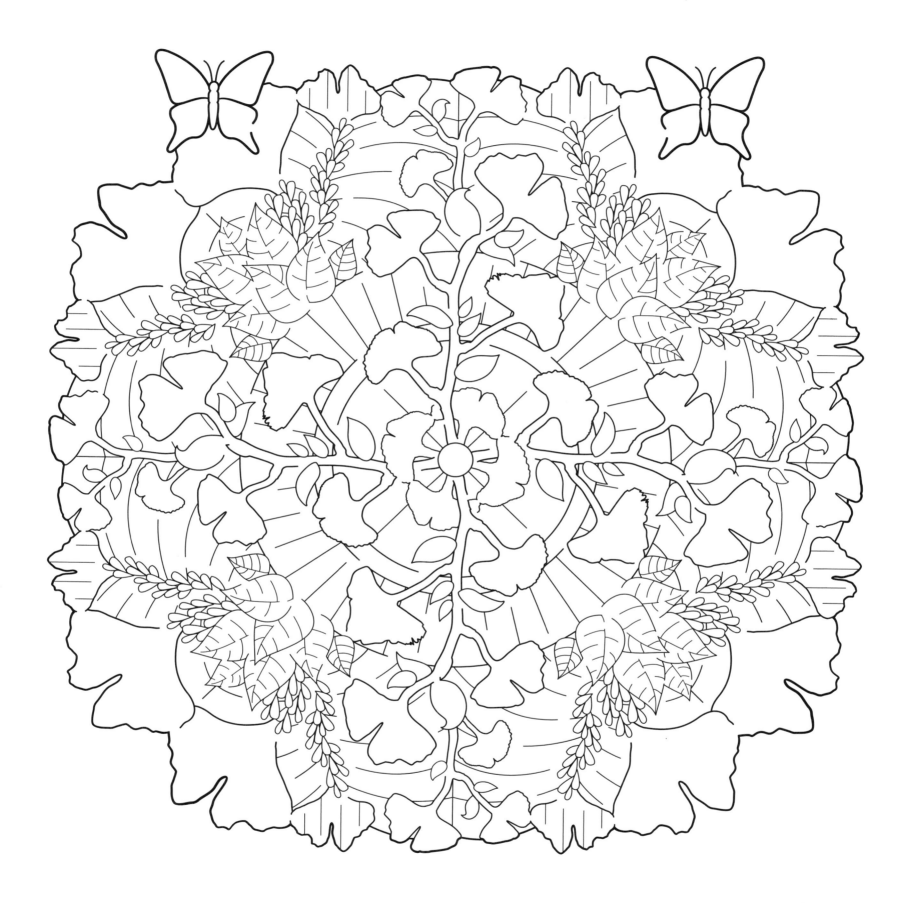

ANSWERS

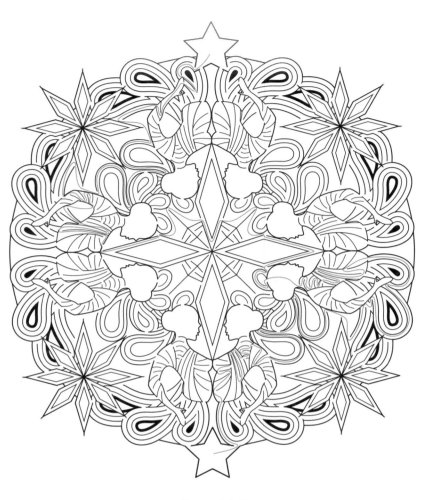

Pages 4 & 5

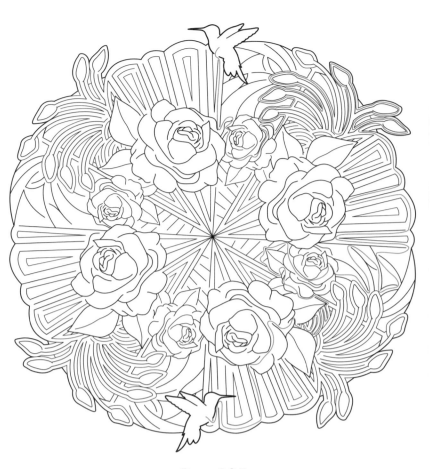

Pages 6 & 7

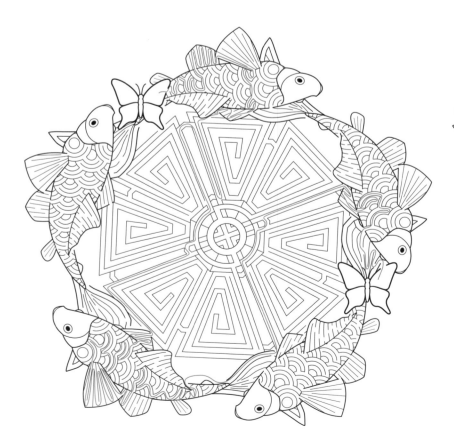

Pages 8 & 9

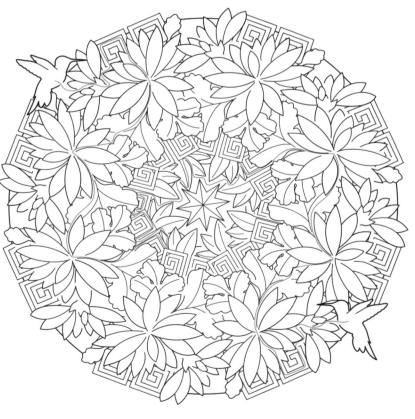

Pages 10 & 11

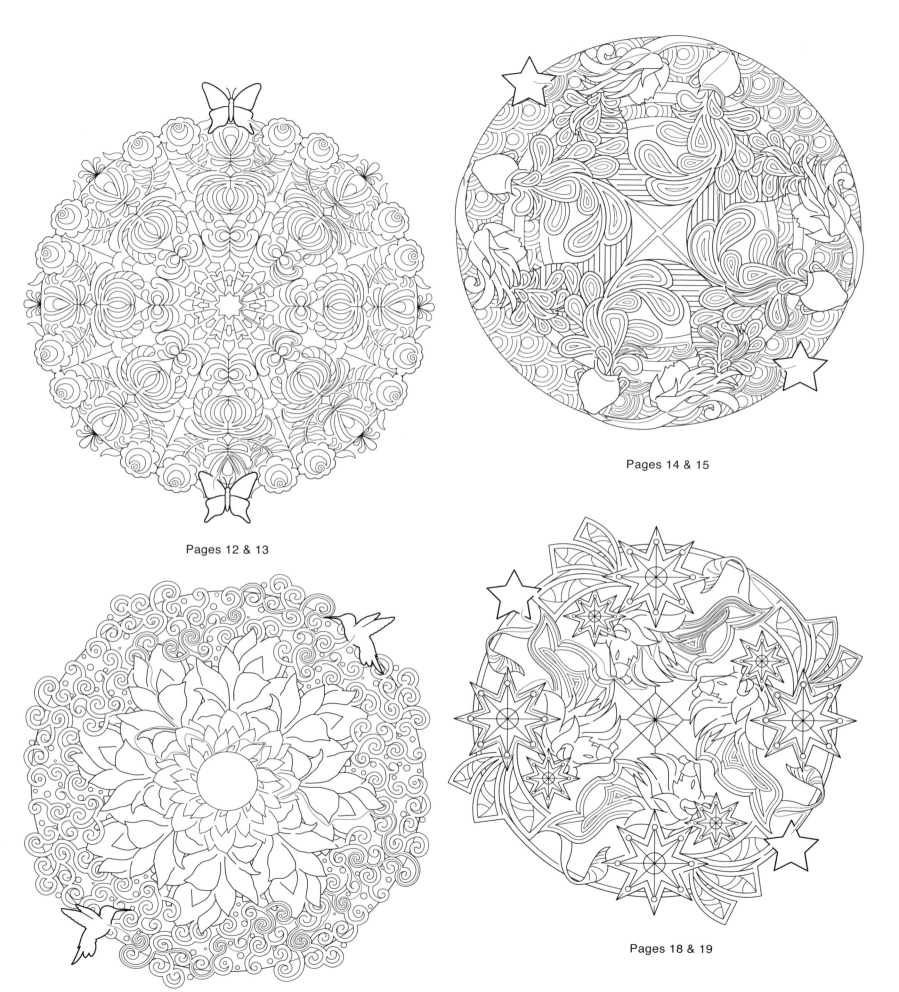

Pages 12 & 13

Pages 14 & 15

Pages 16 & 17

Pages 18 & 19

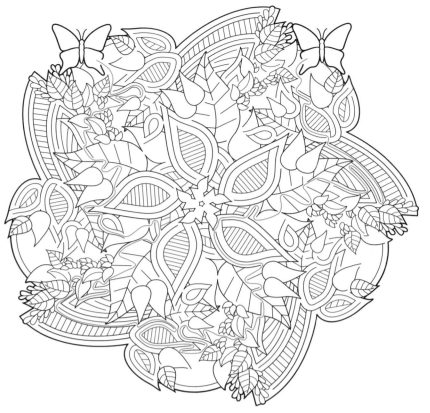

Pages 20 & 21

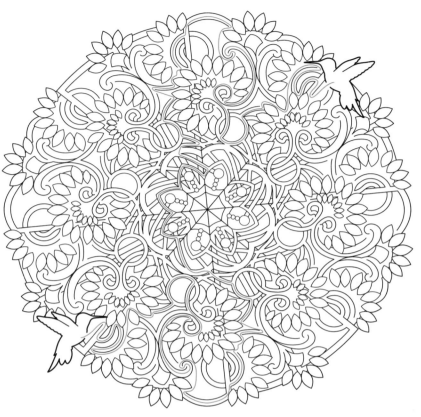

Pages 22 & 23

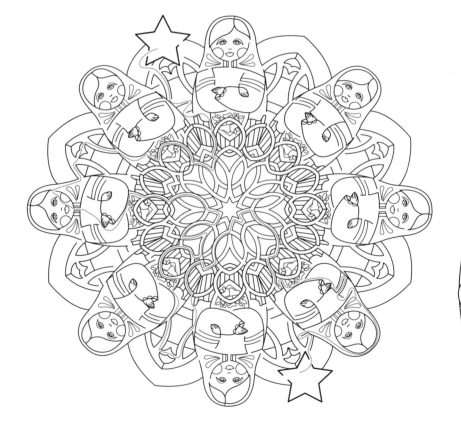

Pages 24 & 25

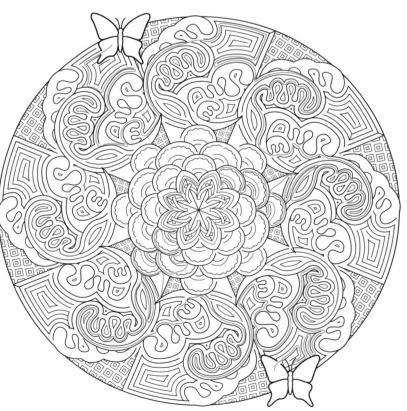

Pages 26 & 27

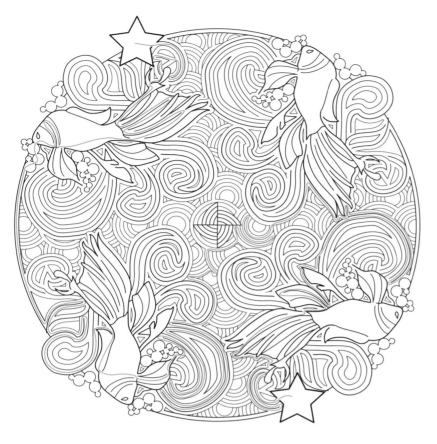

Pages 28 & 29

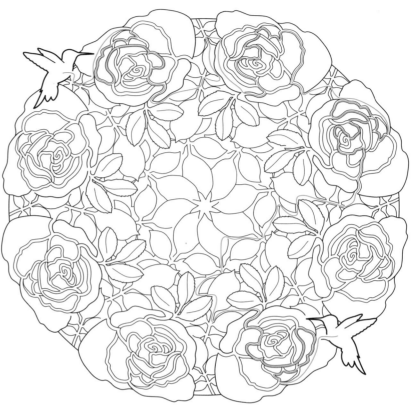

Pages 30 & 31

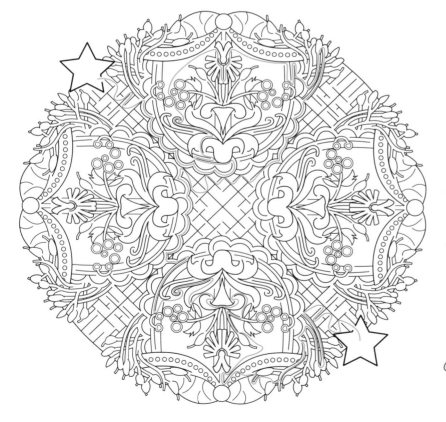

Pages 32 & 33

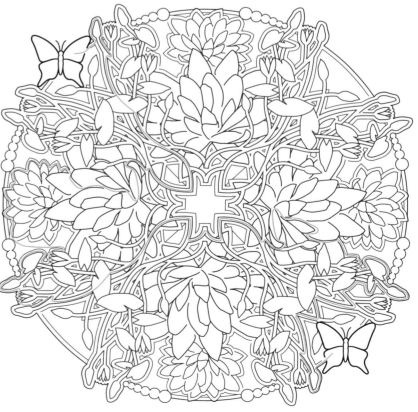

Pages 34 & 35

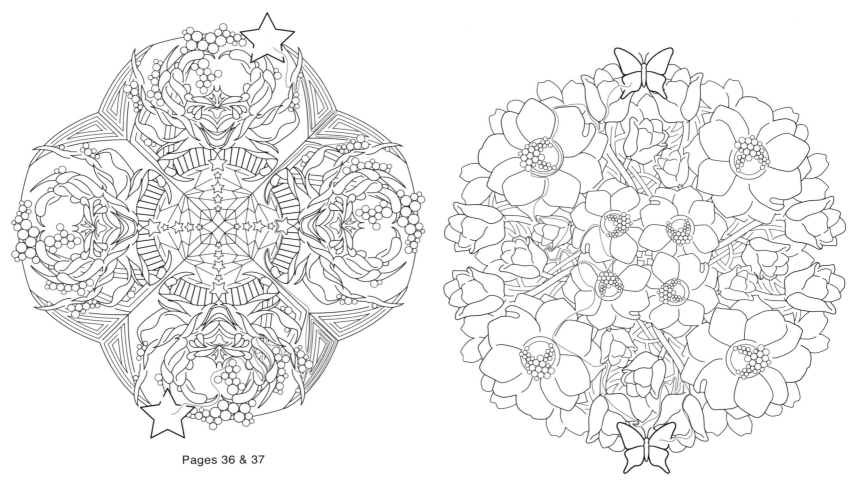

Pages 36 & 37

Pages 38 & 39

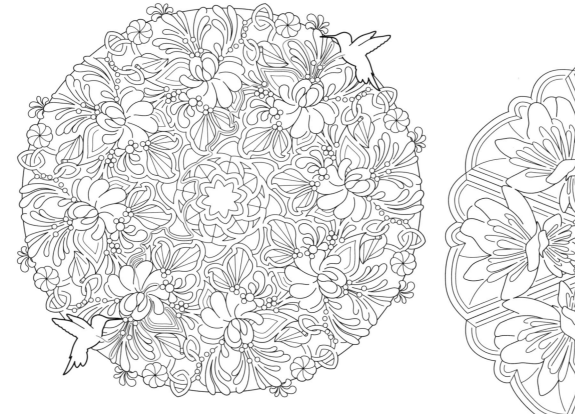

Pages 40 & 41

Pages 42 & 43

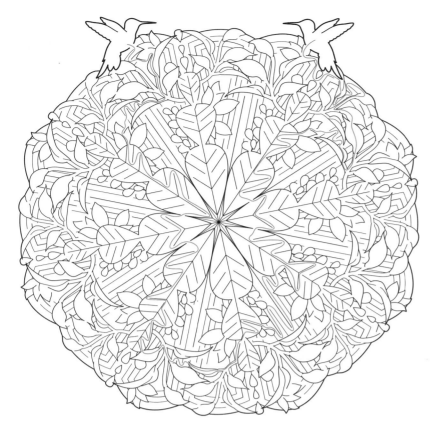

Pages 44 & 45

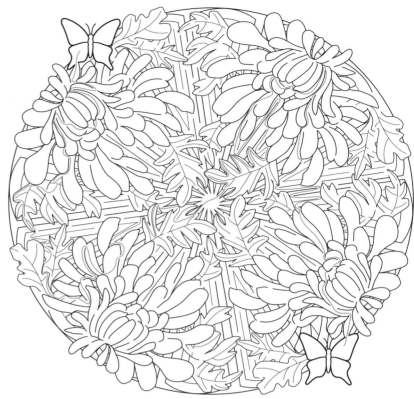

Pages 46 & 47

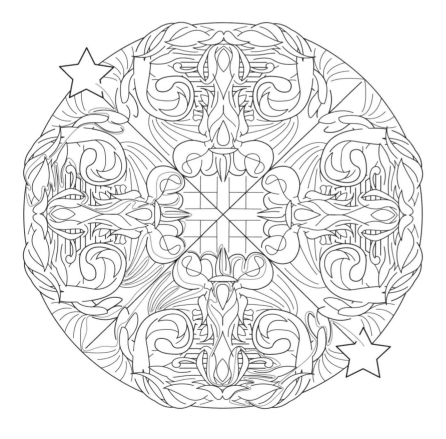

Pages 48 & 49

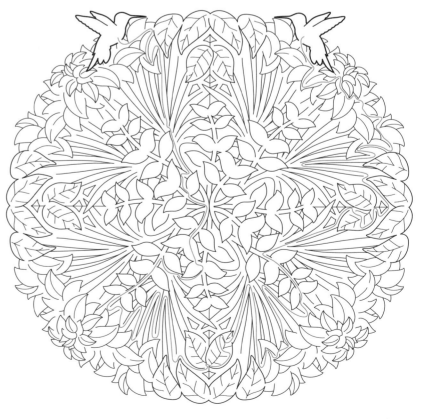

Pages 50 & 51

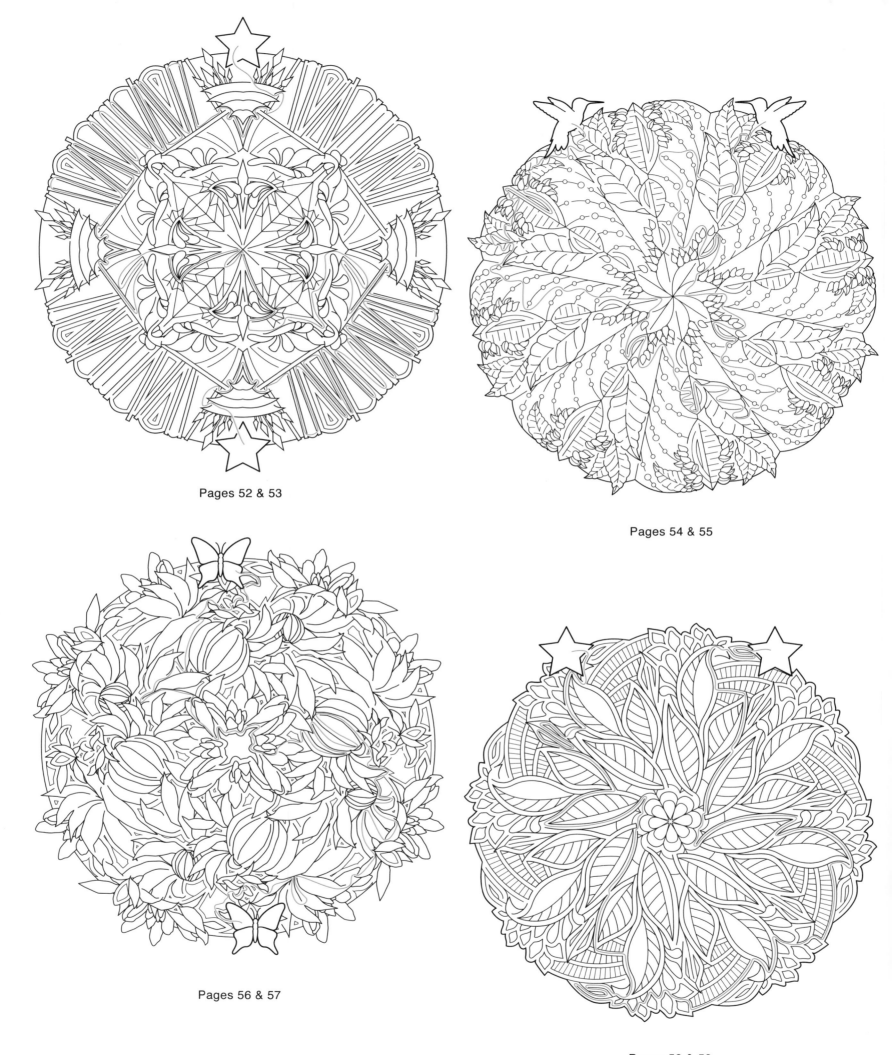

Pages 52 & 53

Pages 54 & 55

Pages 56 & 57

Pages 58 & 59

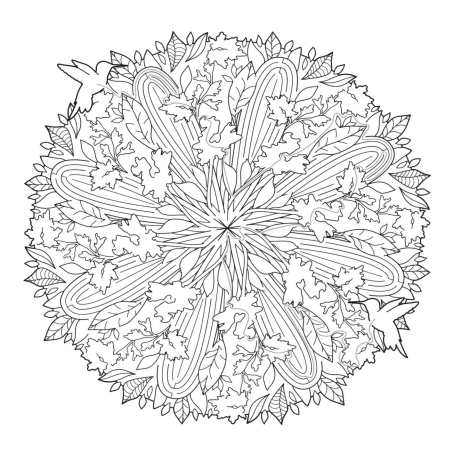

Pages 60 & 61

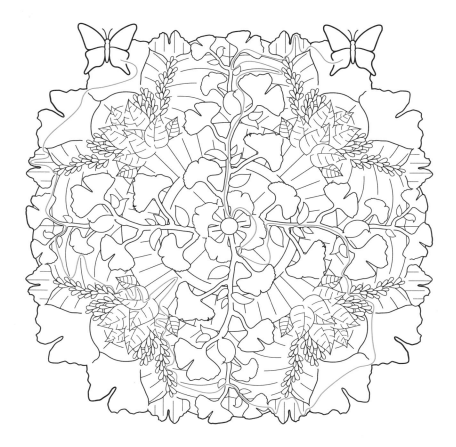

Pages 62 & 63

Many thanks to Sam Freund
for repeatedly testing these mazes
until they were perfect!

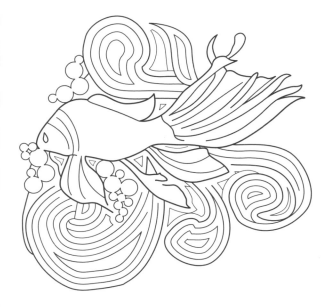

Get Creative 6
An Imprint of Mixed Media Resources
161 Avenue of the Americas, New York, NY 10013

Illustrations by Aurélie Ronfaut from the "100 mandalas étincelants"
© Mango, Paris – 2015

ISBN: 978-1-942021-46-9

Printed in China

1 3 5 7 9 10 8 6 4 2

First Edition